Calligraphy Alphabets Made Easy

Margaret Shepherd

A Perigee Book

Contents

Perigee Books
Published by The Berkley Publishing Group
A division of Penguin Putnam Inc.
375 Hudson Street
New York, New York 10014

The Penguin Putnam Inc. World Wide Web site address is
http://www.penguinputnam.com

Library of Congress Cataloging-in-Publication Data

Shepherd, Margaret
 Calligraphy alphabets made easy.

 1. Calligraphy. 2. Alphabets. I. Title.
Z43.S5426 1986 745.6'1 86–8150
ISBN 0–399–51257–8 (pbk.)

Cover design © 1986 by Mike Stromberg

Printed in the United States of America
30 29 28 27 26 25 24

Quotation from Speak, Memory by Vladimir Nabokov
Used by permission of Mrs. Vera Nabokov.

Special thanks go to Stanley Kugell, Jane Reed,
Alison Lewis, David Friend, Jasper Friend, and
Zack Friend; and to Maria Kuntz for her
work on paste-up and proofreading.

OTHER BOOKS BY MARGARET SHEPHERD
Learning Calligraphy • A Book of Lettering, Design, and History
Using Calligraphy • A Workbook of Alphabets, Projects, and Techniques
Borders for Calligraphy • How to Design a Decorated Page
Capitals for Calligraphy • A Sourcebook of Decorative Letters
Calligraphy Made Easy • A Beginner's Workbook
Calligraphy Projects for Pleasure and Profit
Calligraphy Now • New Light on Traditional Letters
Calligraphy Alphabets Made Easy
Basics of the New Calligraphy

Materials

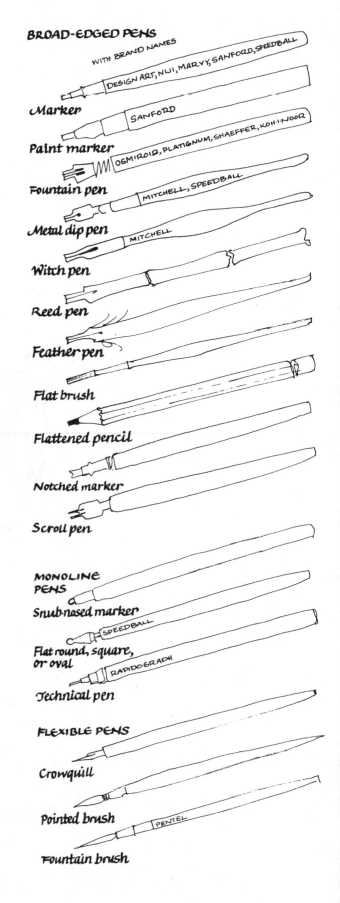

BROAD-EDGED PENS
WITH BRAND NAMES

DESIGN ART, NIJI, MARVY, SANFORD, SPEEDBALL
Marker

SANFORD
Paint marker

OSMIROID, PLATIGNUM, SHAEFFER, KOH-I-NOOR
Fountain pen

MITCHELL, SPEEDBALL
Metal dip pen

MITCHELL
Witch pen

Reed pen

Feather pen

Flat brush

Flattened pencil

Notched marker

Scroll pen

MONOLINE PENS
Snub-nosed marker

SPEEDBALL
Flat round, square, or oval

RAPIDOGRAPH
Technical pen

FLEXIBLE PENS
Crowquill

PENTEL
Pointed brush

Fountain brush

USING THIS BOOK

Use this book to sample the hundreds of alphabet styles that the pen puts within your reach. Daily practice is the key to exploring the world of calligraphy; practice new alphabets, review old ones, add individual touches, or invent your own.

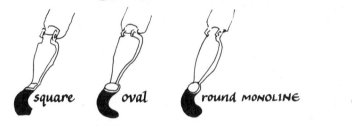

1. Choose the kind of pen shown in the center top line of the alphabet. Most of the alphabets use the broad-edged pen; the rest specify the square, round, or oval monoline pen, or a flexible point. As long as you use the same kind of pen, the size is not crucial—although if you are a beginner, the bigger your practice letter the better!

solid split BROAD-EDGED square oval round MONOLINE FLEXIBLE

2. Provide yourself with the correct guidelines for each alphabet using one of the two techniques detailed on page 4.

3. Holding your pen at the prescribed angle, write each basic stroke at least 25 times — more if you are a beginner or the style is difficult. Practice writing letters in the family groups shown; then try them in words and sentences.

Miss Beverley Delouise
482 Westwood Drive
Birchville
Indiana 45102

4. Apply your new alphabets to each week's practical project. You'll acheive greater understanding of a new style if you put it to work right away.

Use guidelines when you first try each alphabet. Here are two ways to make them:

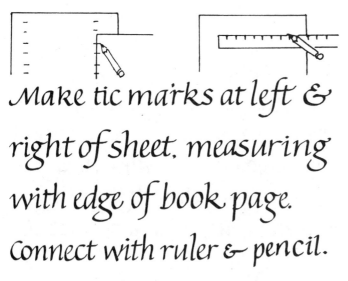

Make tic marks at left & right of sheet, measuring with edge of book page. Connect with ruler & pencil.

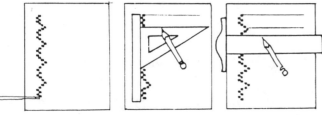

Or measure to fit any width of pen by stacking the recommended number of strokes, and draw the guidelines with a T-square or triangle.

USING THE MASTER

GUIDELINES are given for the size of pen pictured. You can vary them if your pen is another width, if you need a larger or smaller letter, or if you want to make the alphabet style heavier or lighter.

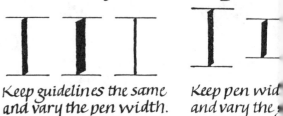

Keep guidelines the same and vary the pen width.

Keep pen wid and vary the

TITLE often includes alternate letter forms.

GUIDELINE MARKS help you measure your own guidelines, as described here at left.

ITAL
A slanted Bas
with Basic It
ILE
straight lette
OC
Round letters

USAGE NOTES are practical pointers abou how to put each alphabet to use~ its streng its weaknesses, its idiosyncracies; hints for spacing; other alphabets that derive from harmonize with this one.

SPECIAL SYMBOLS

LEFTHANDERS' ALPHABETS

☞ This alphabe is suitable fo lefthanders.

...HABETS AND GUIDELINES

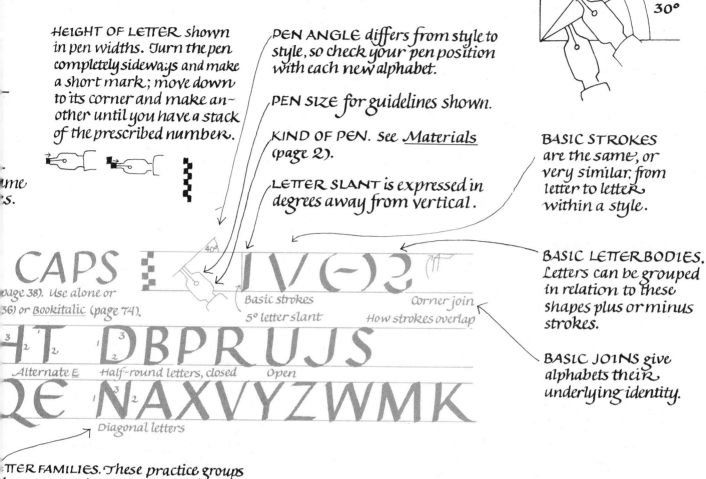

HEIGHT OF LETTER shown in pen widths. Turn the pen completely sideways and make a short mark; move down to its corner and make another until you have a stack of the prescribed number.

PEN ANGLE differs from style to style, so check your pen position with each new alphabet.

PEN SIZE for guidelines shown.

KIND OF PEN. See <u>Materials</u> (page 2).

LETTER SLANT is expressed in degrees away from vertical.

45° pen angle
30°

BASIC STROKES are the same, or very similar, from letter to letter within a style.

BASIC LETTERBODIES. Letters can be grouped in relation to these shapes plus or minus strokes.

BASIC JOINS give alphabets their underlying identity.

...ume
...s.

CAPS ...IV(-)2

...page 38). Use alone or ...36) or <u>Bookitalic</u> (page 74).

Basic strokes
5° letter slant

Corner join
How strokes overlap

...HT DBPRUJS

Alternate E Half-round letters, closed Open

...RE NAXVYZWMK

Diagonal letters

...TTER FAMILIES. These practice groups ...lp you see and emphasize the resem- ...ances between related letters. (If letters ...re shown in alphabetical order, you can ...ok for your own groupings.)

...VEL OF DIFFICULTY

Needs extra practice

Very challenging

ORDER OF STROKES

Construct the letter in this order

DIRECTION OF STROKE

Stroke starts here and ends here.

Everyone needs a plan for the year. Think about your calligraphic talent; your enthusiasms and failings; the alphabets you love and the styles you dread; & what might give you a shot in the arm (!) if you could only master it. Make a list for the day, 365 alphabets from now, when you size up the progress you've made.

Resolutions

1 _____

2 _____

3 _____

4 _____

Signature _ _ _ _ _ _ _ _ _ _ _ _ _

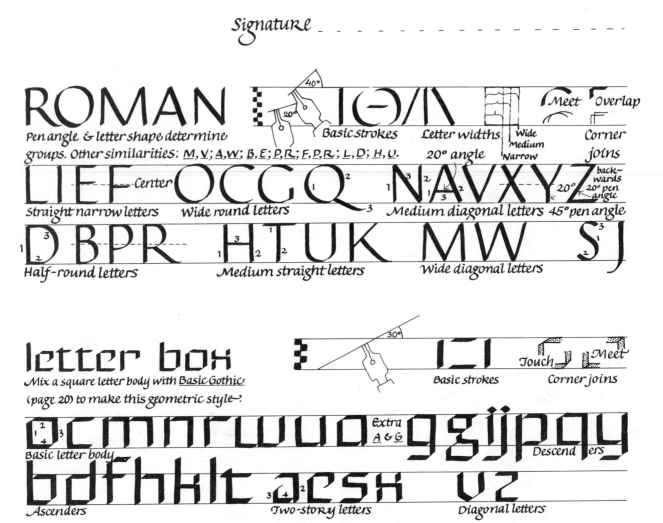

ROMAN

Pen angle & letter shape determine groups. Other similarities: M, V; A, W; B, E; P, R; F, P, R; L, D; H, U.

Basic strokes Letter widths Wide / Medium / Narrow 20° angle Corner joins Meet / Overlap

LIEF Center OCGQ NAVXYZ backwards 20° pen angle

Straight narrow letters Wide round letters Medium diagonal letters 45° pen angle

DBPR HTUK MW SJ

Half-round letters Medium straight letters Wide diagonal letters

letter box

Mix a square letter body with *Basic Gothic* (page 20) to make this geometric style→

Basic strokes Corner joins Touch / Meet

ocmnrwuo Extra A & G ggijpqy

Basic letter body Descenders

bdfhklt aesx vz

Ascenders Two-story letters Diagonal letters

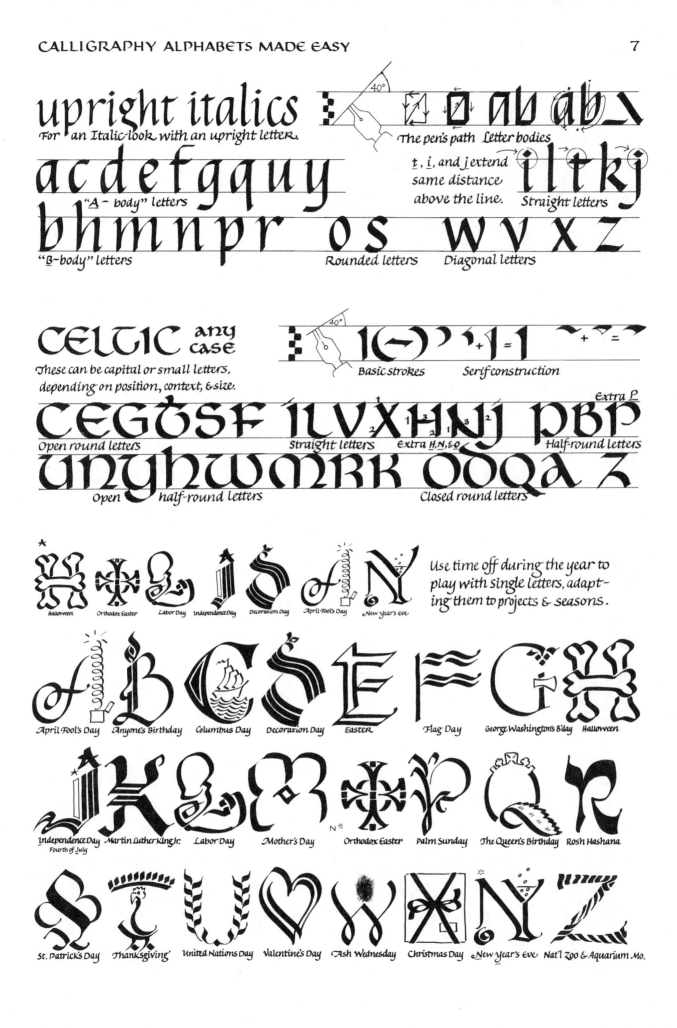

upright italics

For an Italic-look with an upright letter.

The pen's path Letter bodies

t, *i*, and *j* extend same distance above the line.

acdefgquy

"A - body" letters Straight letters: iltkj

bhmnpr os wvxz

"B-body" letters Rounded letters Diagonal letters

CELTIC any case

These can be capital or small letters, depending on position, context, & size.

Basic strokes Serif construction

CEGOSF ILVXHNJ PBP Extra P

Open round letters Straight letters Extra H,N,&O Half-round letters

UNYHWMRK ODQA Z

Open half-round letters Closed round letters

Use time off during the year to play with single letters, adapting them to projects & seasons.

Halloween Orthodox Easter Labor Day Independence Day Decoration Day April Fool's Day New Year's Eve

April Fool's Day Anyone's Birthday Columbus Day Decoration Day Easter Flag Day George Washington's B'day Halloween

Independence Day / Fourth of July Martin Luther King Jr. Labor Day Mother's Day Orthodox Easter Palm Sunday The Queen's Birthday Rosh Hashana

St. Patrick's Day Thanksgiving United Nations Day Valentine's Day Ash Wednesday Christmas Day New Year's Eve Nat'l Zoo & Aquarium Mo.

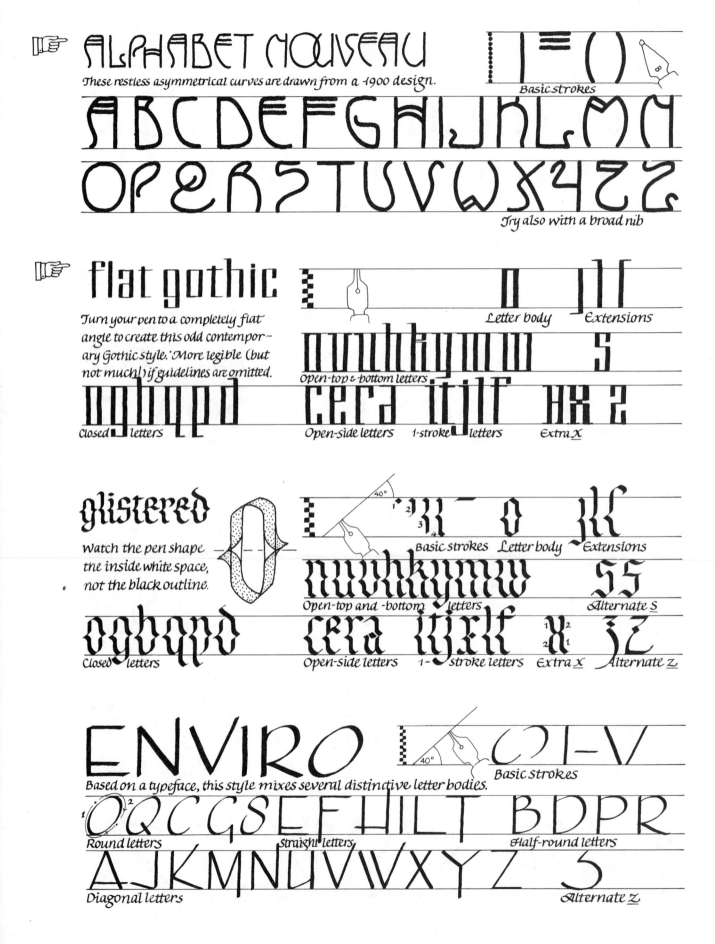

ALPHABET NOUVEAU

These restless asymmetrical curves are drawn from a 1900 design.

Basic strokes

ABCDEFGHIJKLMN

OPQRSTUVWXYZZ

Try also with a broad nib

flat gothic

Turn your pen to a completely flat angle to create this odd contemporary Gothic style. More legible (but not much!) if guidelines are omitted.

Letter body Extensions

Open-top & bottom letters

Closed letters Open-side letters 1-stroke letters Extra X

glistered

watch the pen shape the inside white space, not the black outline.

Basic strokes Letter body Extensions

Alternate S

Closed letters Open-side letters 1-stroke letters Extra X Alternate Z

ENVIRO

Based on a typeface, this style mixes several distinctive letter bodies.

Basic strokes

OQCGSEFHILT BDPR

Round letters Straight letters Half-round letters

AJKMNUVWXYZ 3

Diagonal letters Alternate Z

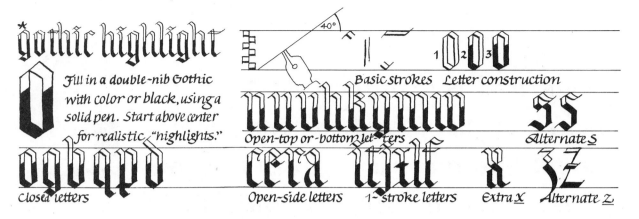

gothic highlight

Fill in a double-nib Gothic with color or black, using a solid pen. Start above center for realistic "highlights."

Basic strokes Letter construction

Open-top or-bottom letters Alternate S

Closed letters

Open-side letters 1-stroke letters Extra X Alternate Z

What can you do with a new alphabet every day? Letter all 26, choose a few, choose one. Keep a journal; label a bag lunch; greet your students; post today's agenda; say 'I love you.'

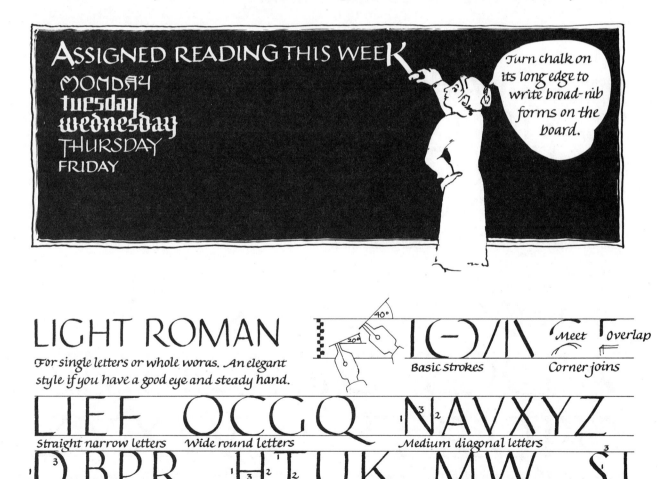

ASSIGNED READING THIS WEEK
MONDAY
tuesday
wednesday
THURSDAY
FRIDAY

Turn chalk on its long edge to write broad-nib forms on the board.

LIGHT ROMAN

For single letters or whole words. An elegant style if you have a good eye and steady hand.

Basic strokes Meet Overlap
Corner joins

LIEF OCGQ NAVXYZ

Straight narrow letters Wide round letters Medium diagonal letters

DBPR HTUK MW SJ

Full and narrow half-round letters Medium straight letters Wide diagonal letters

January 14 is Printing Ink Day. To make sure the ink ends up where you want it, letter properly-prepared artwork for reproduction. Use opaque black ink & smooth white Bristol board.* Leave ample margins, where important instructions can be written; don't ever rely on verbal orders. Let your printer instruct you, and remember, "Don't worry about asking stupid questions; they're easier to handle than stupid mistakes."

*or other smooth, heavy paper.

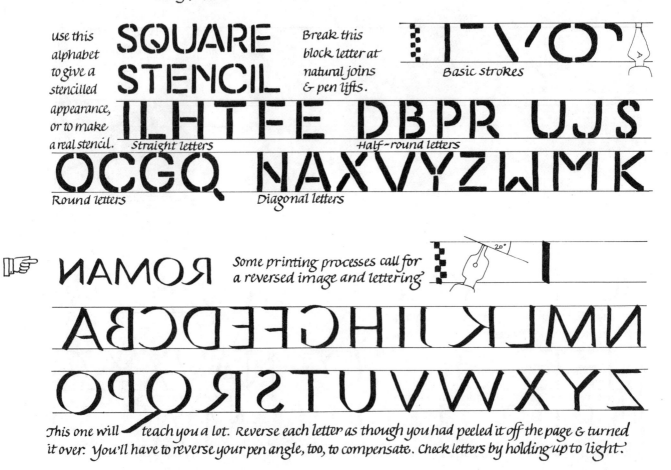

use this alphabet to give a stencilled appearance, or to make a real stencil.

Break this block letter at natural joins & pen lifts.

Basic strokes

ILHTFE DBPR UJS
Straight letters Half-round letters

OCGQ NAXVYZWMK
Round letters Diagonal letters

☞ ИAMOЯ

Some printing processes call for a reversed image and lettering.

ИMLKJIHGꟻEDCBA
OꟼOЯꙄTUVWXYꙄ

This one will ── teach you a lot. Reverse each letter as though you had peeled it off the page & turned it over. You'll have to reverse your pen angle, too, to compensate. Check letters by holding up to light.

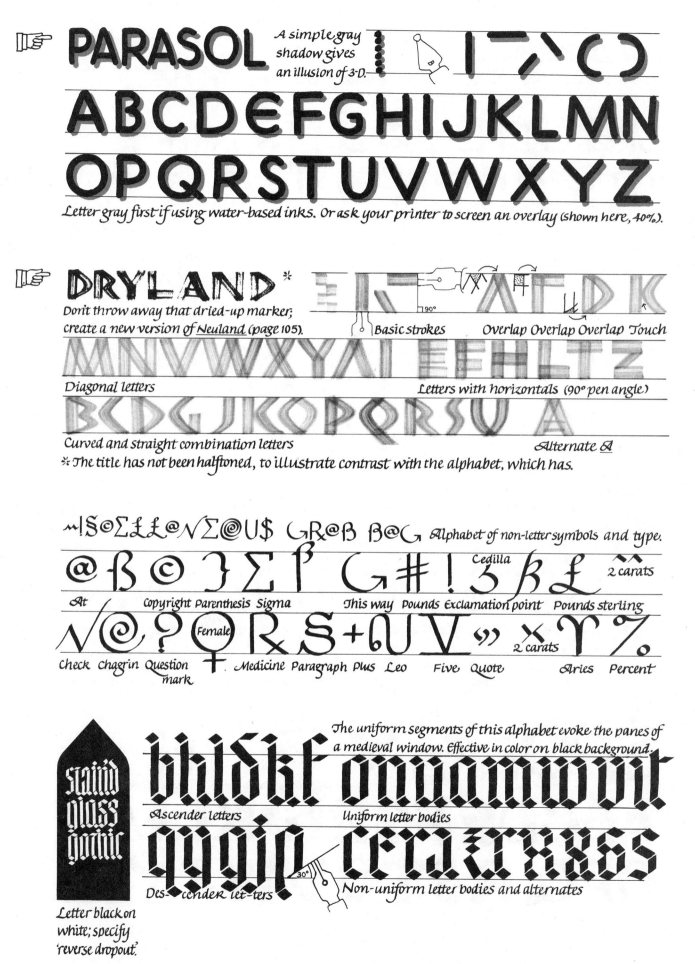

☞ **PARASOL** A simple gray shadow gives an illusion of 3-D.

ABCDEFGHIJKLMN
OPQRSTUVWXYZ

Letter gray first if using water-based inks. Or ask your printer to screen an overlay (shown here, 40%).

☞ **DRYLAND** *
Don't throw away that dried-up marker; create a new version of <u>Neuland</u> (page 105).

Basic strokes Overlap Overlap Overlap Touch

Diagonal letters Letters with horizontals (90° pen angle)

Curved and straight combination letters Alternate A
※ The title has not been halftoned, to illustrate contrast with the alphabet, which has.

MISCELLANEOUS GRAB BAG Alphabet of non-letter symbols and type.

@ ß ©) Σ ᴘ G # ! 3 ß £ Cedilla ˆˆ 2 carats

At Copyright Parenthesis Sigma This way Pounds Exclamation point Pounds sterling

N C ? ♀ Q R S + U V ,, ✗ ♈ %
Female 2 carats

Check Chagrin Question ✝ Medicine Paragraph Plus Leo Five Quote Aries Percent
mark

The uniform segments of this alphabet evoke the panes of a medieval window. Effective in color on black background.

stained glass gothic

bhldkf onvamwvit
Ascender letters Uniform letter bodies

gggjp crraɜrxɤ6s
Descender let-ters Non-uniform letter bodies and alternates
30°

Letter black on white; specify 'reverse dropout.'

☞ lower kingdom 八 ハ 丁 二 A few basic strokes

Like many basics of culture, the tools and techniques of Chinese calligraphy differ fundamentally from those of the West. Use uncoated paper, thick ink, & a soft brush.

a b c d e f g h i j k l m
n o p q r s t u v w x y z

How to hold the brush

☞ copper brush Letter slant

Compare to <u>Copperplate</u> (page 86) to see how these brushstrokes are more fluid, these hairlines thinner.

Basic strokes
Hold brush straight up or pointing left.

o a c e r s x j g y q h f
Round letters Descend-er let-ters

b l h k d i t m n u v w
Ascender letters **Arched letters**

☞ WAITY

Soft paper? Turn it to your advantage.

Create thicks & thins by slowing & speeding a wet brush on absorbent paper. (Try also an aerosol spray can)

Stop | 1 | 2 | 60 | Stop | 3 Try gradual speed change.

Basic strokes

A B C D E F G H I J K L M N
O P Q R S T U V W X Y Z

Extra W

Note as you work that the dots may continue to grow for a minute or two after you lift the brush off the paper.

☞ SPONGY

Use a very wet brush, and very absorbent paper.

Fast | slow | ● stop

Basic strokes

A B C D E F G H I J K L M N
O P Q R S T U V W X Y Z

Although Roman letters written with a broad-edged pen have become the standard alphabet of the West, a quarter of the world's calligraphers (a billion Chinese) write with the pointed brush, holding it vertically above the paper. This week, just before Chinese New Year, experiment with a tapered brush on a variety of papers, rough, smooth, spongy, or impervious. Hold the handle pointing right, left, or up; keep the brush hairs wet or dry; apply pressure or maintain a hairline; work with deliberateness or speed.

Shown here; the characters for 'calligraphy.'

BAMBOO

Basic strokes

Press →
Let up →
Press →

Built on brush strokes from Chinese painting. On larger letters, add bamboo joints, and leaf sprouts for extra appeal & Oriental flavor.

ABCDEFGHIJKLM
NOPQRSTUVWXYZ

dry brush

Based on Basic Italic (page 36). Move fast in mid-stroke.

Basic strokes

a c d e g g u y f t i j l

"A-body" letters Straight letters

b h m n p r o s w x v z k

"B-body" letters Curved letters Diagonal letters

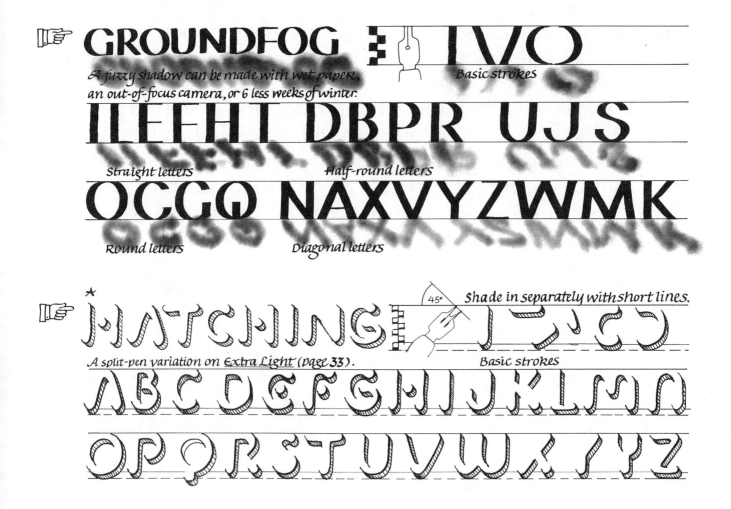

☞ GROUNDFOG IVO *Basic strokes*

A fuzzy shadow can be made with wet paper, an out-of-focus camera, or 6 less weeks of winter.

ILEFHT DBPR UJS

Straight letters *Half-round letters*

OCGQ NAXVYZWMK

Round letters *Diagonal letters*

☞ ⭑ HATCHING 45° *Shade in separately with short lines.*

A split-pen variation on Extra Light *(page 33).* *Basic strokes*

ABCDEFGHIJKLMN

OPQRSTUVWXYZ

shaded letters give the calligrapher a visual tool of great power, versatility, & grace. using the broad-edged pen, you can imagine and make a flat, two-dimensional letter that casts a shadow, or shape the contours of a solid, three-dimensional one. Experiment with gray and colors, and with the sharp- or fuzzy-edged shadows, as shown here, that signal a six-week difference in winter's length to the traditional groundhog on February 2.

WINTER **SPRING**

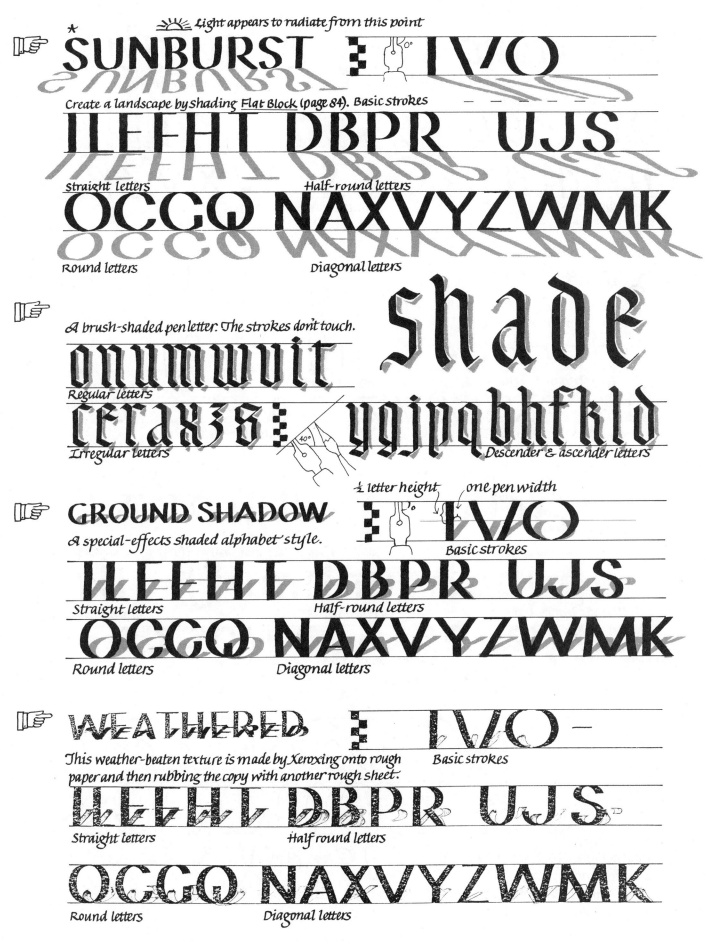

SUNBURST

Light appears to radiate from this point

IVO

Create a landscape by shading Flat Block (page 84). Basic strokes

ILEFHT DBPR UJS

Straight letters — Half-round letters

OCGQ NAXVYZWMK

Round letters — Diagonal letters

A brush-shaded pen letter. The strokes don't touch.

shade

onumwvit

Regular letters

cɛraxʒꞄ

Irregular letters

ygjpqbhfkld

Descender & ascender letters

GROUND SHADOW

A special-effects shaded alphabet style.

½ letter height one pen width

IVO

Basic strokes

ILEFHT DBPR UJS

Straight letters — Half-round letters

OCGQ NAXVYZWMK

Round letters — Diagonal letters

WEATHERED IVO —

This weather-beaten texture is made by Xeroxing onto rough paper and then rubbing the copy with another rough sheet.

Basic strokes

ILEFHT DBPR UJS

Straight letters — Half round letters

OCGQ NAXVYZWMK

Round letters — Diagonal letters

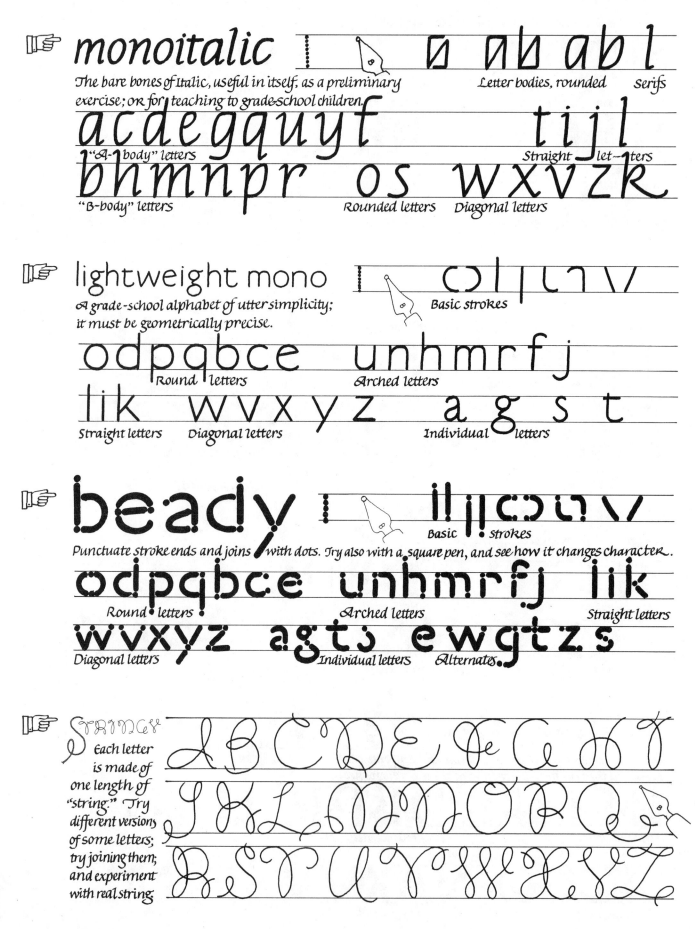

monoitalic

The bare bones of Italic, useful in itself, as a preliminary exercise; or for teaching to grade-school children.

Letter bodies, rounded Serifs

acdegquyf tijl

"A-body" letters Straight letters

bhmnpr os wxvzk

"B-body" letters Rounded letters Diagonal letters

lightweight mono

A grade-school alphabet of utter simplicity; it must be geometrically precise.

Basic strokes

odpqbce unhmrfj

Round letters Arched letters

lik wvxyz a g s t

Straight letters Diagonal letters Individual letters

beady

Punctuate stroke ends and joins with dots. Try also with a square pen, and see how it changes character.

Basic strokes

odpqbce unhmrfj lik

Round letters Arched letters Straight letters

wvxyz agts ewgtzs

Diagonal letters Individual letters Alternates

stringy

Each letter is made of one length of "string." Try different versions of some letters; try joining them; and experiment with real string

ABCDEFGH

IJKLMNOPQ

RSTUVWXYZ

Pointed serif

Unstable retracing

Frosting a cake with letters is a fascinating exercise in handling a continuous line. Since the ends of a piped line of icing are not particularly pretty, keep breaks to a minimum; but since a doubled-up line of frosting will sag and collapse, avoid precise retracing as well. Not so simple! To make separated letters, turn the bulgy ending to your advantage, exaggerating it for effect, or form letter from many little dots. And try different nozzles; a serrated one for a textured stroke, a flattened one for the familiar thicks and thins of the broad-edged pen.

| Looped retracing | Bulges | Dots | Texture | Broad edge |

COILTIC

A fanciful modern invented style, based on 8th-century coiled Celtic.

Basic strokes Serif and coil construction

ILVXJ CEGTS PB Z

Straight letters Open round letters Half-round letters

angbbwwmmrkf OOQd

half-round letters closed round letters

ITALIC CAPS

A slanted Basic BLOCK (page 38). Use alone or with Basic Italic (page 36) or Bookitalic (page 74).

Basic strokes Corner join
5° letter slant How strokes overlap

ILEFHT DBPRUJS

Straight letters Alternate E Half-round letters, closed Open

OCGQE NAXVYZWMK

Round letters Diagonal letters

SWASH CAPITALS

40°

5°

Basic strokes

with *Basic Italic* (page 36), *Swash Italic* (page 30).
Mix with plain capitals. Don't dilute its decorative impact by using too many swashes in one design.

ABCDEFGHIJKLM
NOPQRSTUVWXYZ

split swash

40°

Some basic strokes

You can touch up cluttered overlaps (*)
with one point of the pen or leave them as they are.

a c d e g a u y f

"A-body" letters

b h m n p r

"B-body" letters

i l j t k

Straight letters

o s v w x z

Diagonal letters

Valentine's Day greetings
can be sentimental, sensible,
sententious, and of course,
sensational. Even scented!
Just be sure they're sent...

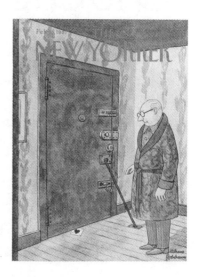

Drawing by Chas. Addams; ©1981 The New Yorker Magazine, Inc.

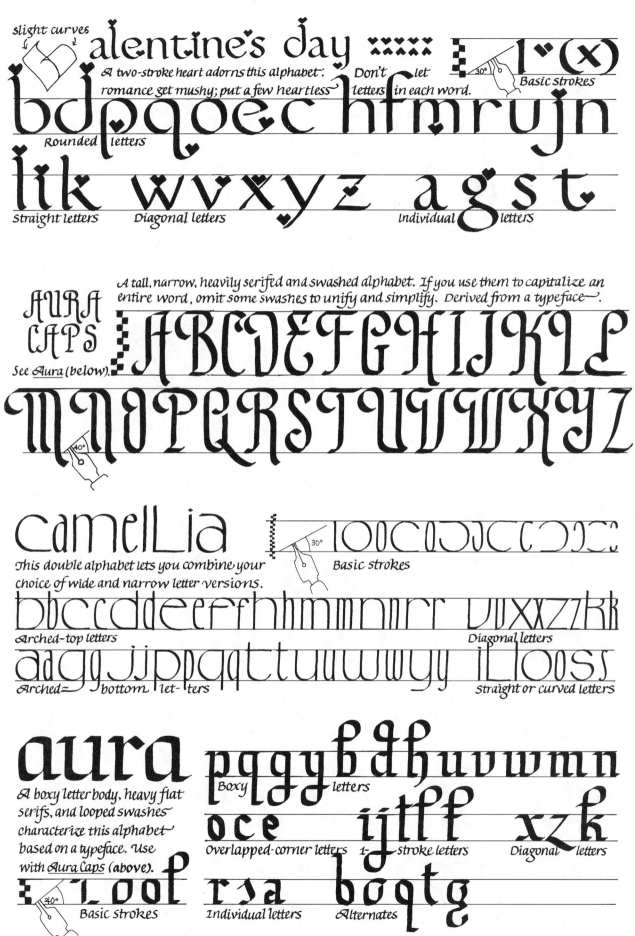

slight curves

Valentine's day ✕✕✕✕ I · (X)

A two-stroke heart adorns this alphabet. Don't let romance get mushy; put a few heartless letters in each word.

30° Basic strokes

bdpqoec hfmruj n

Rounded letters

lik wvxyz a g s t

Straight letters Diagonal letters Individual letters

AURA CAPS

A tall, narrow, heavily serifed and swashed alphabet. If you use them to capitalize an entire word, omit some swashes to unify and simplify. Derived from a typeface—.

See Aura (below).

ABCDEFGHIJKL

MNOPQRSTUVWXYZ

40°

camellia

This double alphabet lets you combine your choice of wide and narrow letter versions.

30° Basic strokes

bbccddeeffhhmmnnrr uvxxzz kk

Arched-top letters Diagonal letters

aaggjjppqqttuuwwyy iLLooss

Arched-bottom letters straight or curved letters

aura

A boxy letter body, heavy flat serifs, and looped swashes characterize this alphabet based on a typeface. Use with Aura Caps (above).

pqgyb dhuvwmn

Boxy letters

oce ijtff xzk

Overlapped-corner letters 1-stroke letters Diagonal letters

40° loof rsa boqtg

Basic strokes Individual letters Alternates

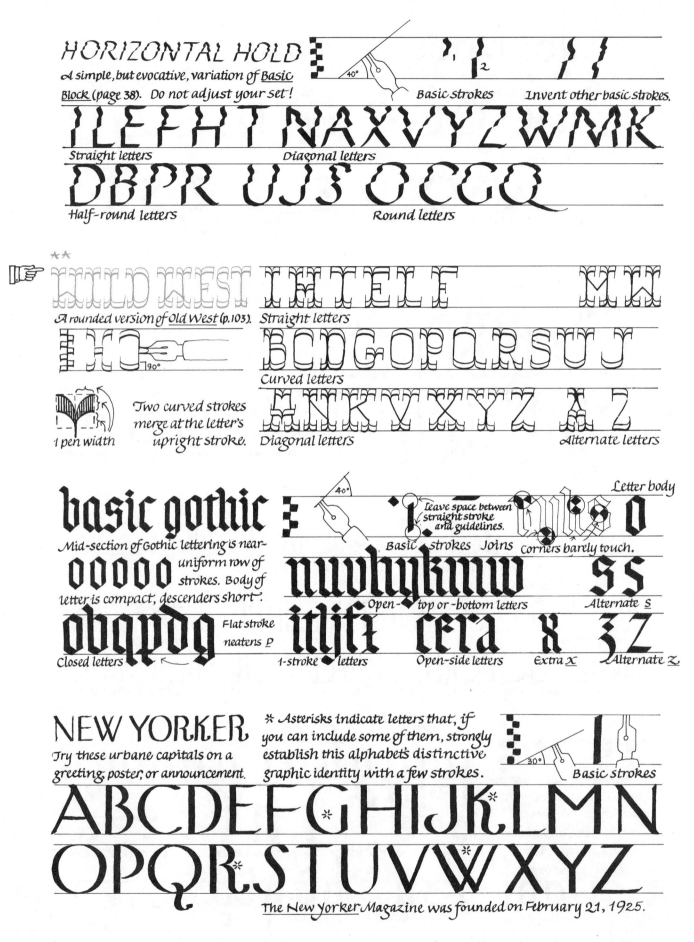

HORIZONTAL HOLD

A simple, but evocative, variation of Basic Block (page 38). Do not adjust your set!

40° Basic strokes Invent other basic strokes.

ILEFHT NAXVYZWMK

Straight letters Diagonal letters

DBPR UJJ OCGQ

Half-round letters Round letters

☆☆

WILD WEST

A rounded version of Old West (p.103). Straight letters

90°

Curved letters

1 pen width *Two curved strokes merge at the letter's upright stroke.* Diagonal letters Alternate letters

basic gothic

Mid-section of Gothic lettering is near-uniform row of strokes. Body of letter is compact, descenders short.

ooooo

obqpdg *Flat stroke neatens P*

Closed letters

40° Letter body

Basic strokes Joins Leave space between straight stroke and guidelines. Corners barely touch.

nuvhykmw ss

Open-top or -bottom letters Alternate S

itlifi cera x 3z

1-stroke letters Open-side letters Extra X Alternate Z

NEW YORKER

Try these urbane capitals on a greeting, poster, or announcement.

** Asterisks indicate letters that, if you can include some of them, strongly establish this alphabet's distinctive graphic identity with a few strokes.*

30° Basic strokes

ABCDEFG*HIJK*LMN
OPQR*STUV*WXYZ

The New Yorker Magazine was founded on February 21, 1925.

heavy copper O ø n u t
 30°
 Basic strokes

Done with a sharp flexible pen, this was known in the 19th century
as a "commercial" hand; i.e., used for everyday business paperwork.

o a c e r s x z j g y q p f
Round letters Individual letters Descenders

b l h k d i t m n u v w
Ascender letters Arched letters

HEAVY CAPS S P C
 30°
 Basic strokes

A nice plain (!) Copperplate with a heavy main
stroke and a minimum of decorative swashes.

A B C D E F G H I J K L M
N O P Q R S T U V W X Y Z

UNWANTED

Don't let it happen

Adopt a kitten or puppy Spay your pet
Contribute money Stavanger Animal Shelter

Cape Cod

THE
CALLIGRAPHER

Some words are engraved in our collective subconscious; by a combination
of alphabet and layout you can work magic on your viewers, slipping a sub-
versive message or visual pun by until they wake up and take a second look.

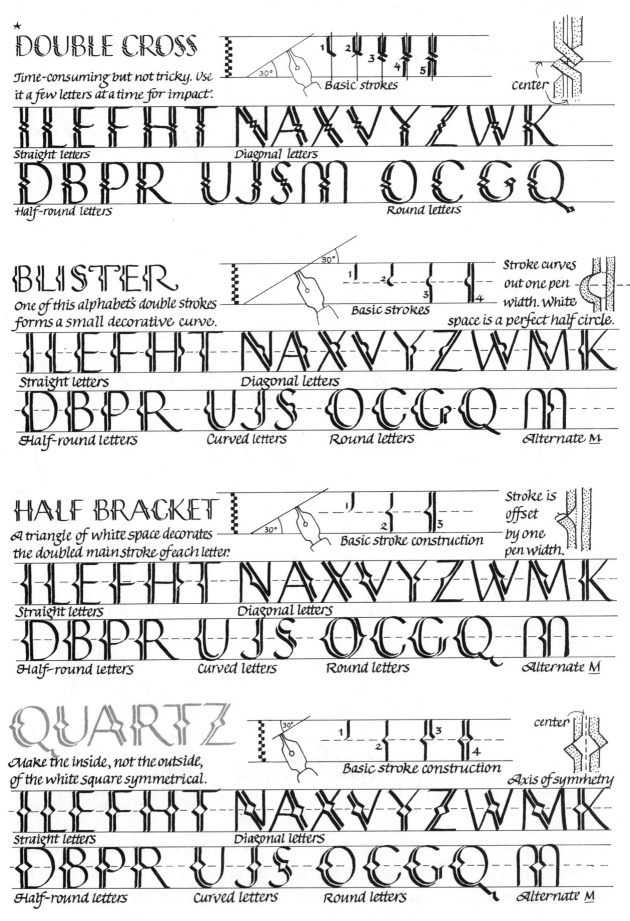

DOUBLE CROSS

Time-consuming but not tricky. Use it a few letters at a time for impact.

Basic strokes

center

ILEFHT NAXVYZWK

Straight letters Diagonal letters

DBPR UJSM OCGQ

Half-round letters Round letters

BLISTER

One of this alphabet's double strokes forms a small decorative curve.

Basic strokes

Stroke curves out one pen width. White space is a perfect half circle.

ILEFHT NAXVYZWMK

Straight letters Diagonal letters

DBPR UJS OCGQ M

Half-round letters Curved letters Round letters Alternate M

HALF BRACKET

A triangle of white space decorates the doubled main stroke of each letter.

Basic stroke construction

Stroke is offset by one pen width.

ILEFHT NAXVYZWMK

Straight letters Diagonal letters

DBPR UJS OCGQ M

Half-round letters Curved letters Round letters Alternate M

QUARTZ

Make the inside, not the outside, of the white square symmetrical.

Basic stroke construction

center

Axis of symmetry

ILEFHT NAXVYZWMK

Straight letters Diagonal letters

DBPR UJS OCGQ M

Half-round letters Curved letters Round letters Alternate M

This is Leap Day, added every four years* to make our calendar keep pace with reality. Use the ampersand instead of 'and' (& vice versa) when your line of words threatens to not quite fit the space provided. The difference between the width of <u>and</u> and the ampersand can sometimes decide you in favor of an &. Of course, ampersands can also just adorn & entertain.

*Except the year 2000.

During a Leap Year, adjust dates mentioned after March 1 by subtracting 1.

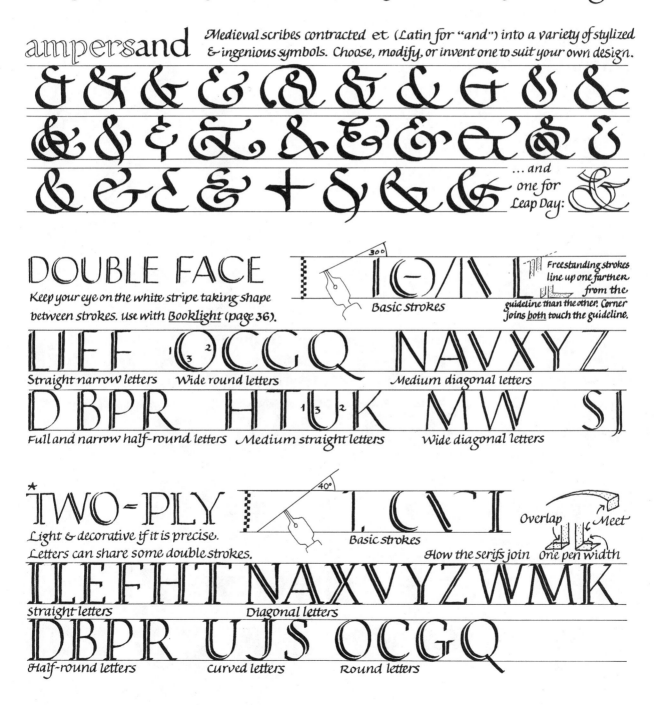

ampersand — Medieval scribes contracted et (Latin for "and") into a variety of stylized & ingenious symbols. Choose, modify, or invent one to suit your own design.

...and one for Leap Day:

DOUBLE FACE

Keep your eye on the white stripe taking shape between strokes. Use with <u>Booklight</u> (page 36).

Basic strokes

Freestanding strokes line up one farther from the guideline than the other. Corner joins <u>both</u> touch the guideline.

LIEF — Straight narrow letters
OCGQ — Wide round letters
NAVXYZ — Medium diagonal letters

DBPR — Full and narrow half-round letters
HTUK — Medium straight letters
MW — Wide diagonal letters
SJ

*TWO-PLY

Light & decorative if it is precise. Letters can share some double strokes.

Basic strokes

Overlap Meet

How the serifs join One pen width

ILEFHT — straight letters
NAXVYZWMK — Diagonal letters

DBPR — Half-round letters
UJS — Curved letters
OCGQ — Round letters

The first week of March is Procrastination Week, when many people decide they will put off losing weight. Celebrate with a banquet of heavy letters, and experiment with fat versions of your regular alphabet styles. But inside every fat letter is a thin letter trying to get out—the imaginary pathway the pen follows. Keep your mind's eye on this & on interior white spaces.

The pen's path

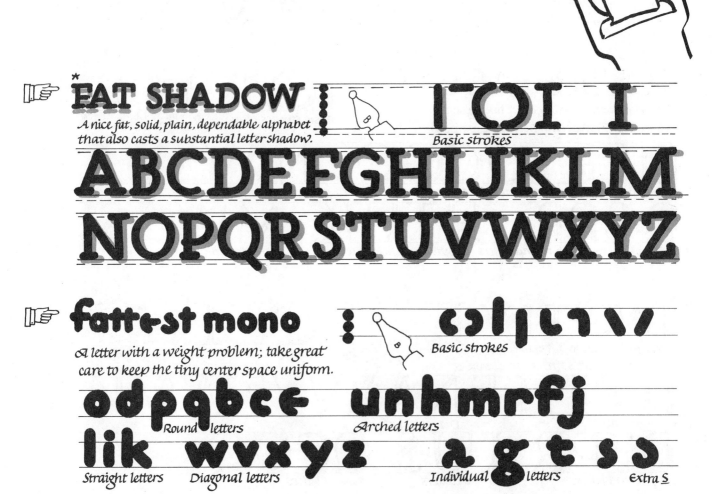

👉 *FAT SHADOW*

A nice fat, solid, plain, dependable alphabet that also casts a substantial letter shadow.

Basic strokes

ABCDEFGHIJKLM
NOPQRSTUVWXYZ

👉 **fattest mono**

A letter with a weight problem; take great care to keep the tiny center space uniform.

Basic strokes

odpqbce **unhmrfj**

Round letters *Arched letters*

lik **wvxyz** **agtss**

Straight letters *Diagonal letters* *Individual letters* *Extra S*

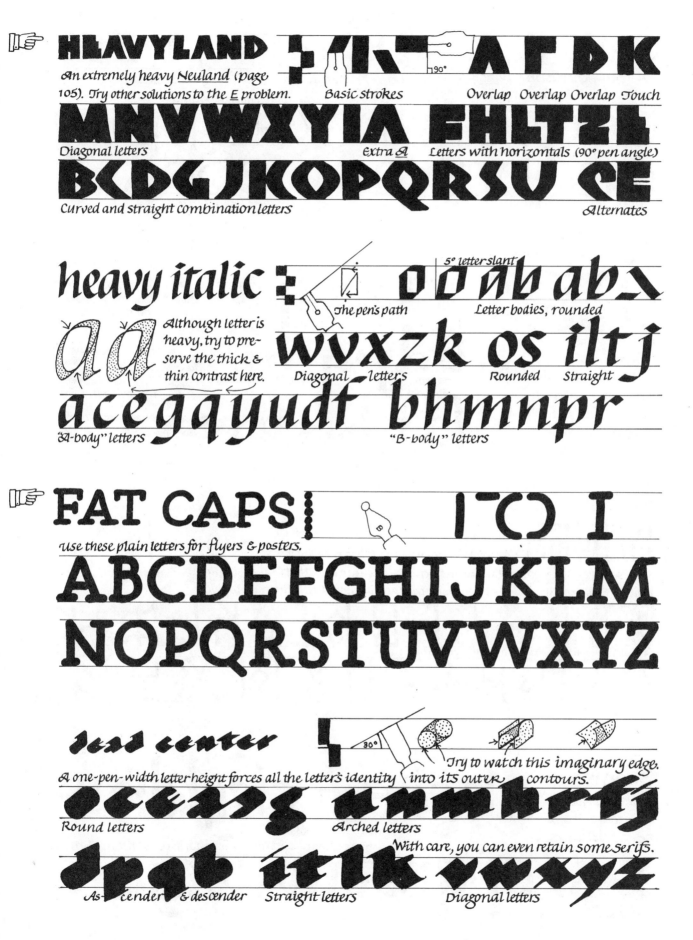

HEAVYLAND

An extremely heavy Neuland (page 105). Try other solutions to the E problem.

Basic strokes

Overlap Overlap Overlap Touch

Diagonal letters Extra A Letters with horizontals (90° pen angle)

Curved and straight combination letters Alternates

heavy italic

Although letter is heavy, try to preserve the thick & thin contrast here.

5° letter slant

The pen's path Letter bodies, rounded

Diagonal letters Rounded Straight

"A-body" letters "B-body" letters

FAT CAPS

Use these plain letters for flyers & posters.

ABCDEFGHIJKLM
NOPQRSTUVWXYZ

dead center

A one-pen-width letter height forces all the letter's identity into its outer contours. Try to watch this imaginary edge.

Round letters Arched letters

With care, you can even retain some serifs.

Ascender & descender Straight letters Diagonal letters

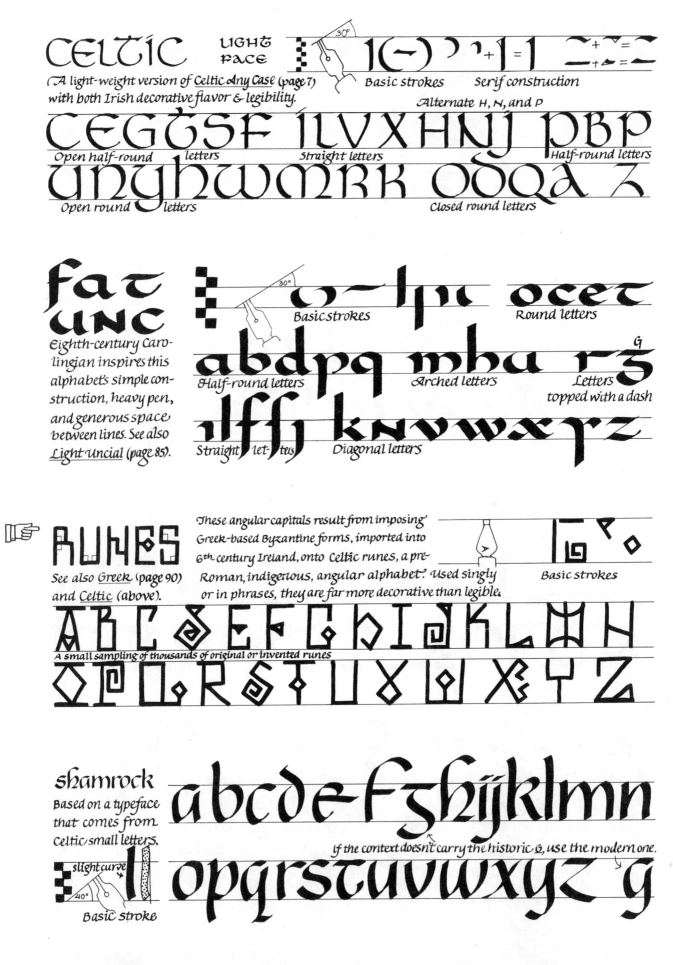

CELTIC LIGHT FACE

(A light-weight version of Celtic Any Case (page 7) with both Irish decorative flavor & legibility.

Basic strokes Serif construction

Alternate H, N, and P

CEGΓSF ILVXHNJ PBP

Open half-round letters Straight letters Half-round letters

UNGHWMRK ODQA Z

Open round letters Closed round letters

fat UNC

Eighth-century Carolingian inspires this alphabet's simple construction, heavy pen, and generous space between lines. See also Light Uncial (page 85).

Basic strokes Round letters

abdpq mhu rG

Half-round letters Arched letters Letters topped with a dash

ilffj knvwxyz

Straight letters Diagonal letters

☞ RUNES

See also Greek (page 90) and Celtic (above).

These angular capitals result from imposing Greek-based Byzantine forms, imported into 6th century Ireland, onto Celtic runes, a pre-Roman, indigenous, angular alphabet. Used singly or in phrases, they are far more decorative than legible.

Basic strokes

A B C S E F G H I K L M H

A small sampling of thousands of original or invented runes

O P Q R S T U V W X Y Z

shamrock

Based on a typeface that comes from Celtic small letters.

abcdefghijklmn

If the context doesn't carry the historic G, use the modern one.

slight curve

opqrstuvwxyz g

40°

Basic stroke

SHAMROCK CAP

Adapted from a typeface, this graceful style can be used on its own or with shamrock small letters (page 26).

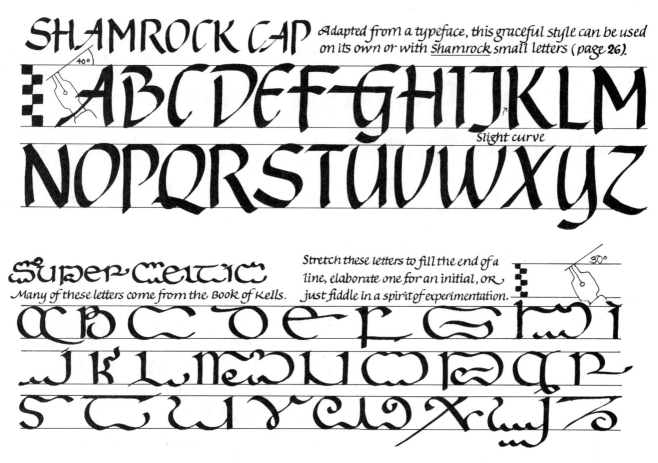

ABC DEF GHIJKLM
NOPQRSTUVWXYZ

Slight curve

Super Celtic

Many of these letters come from the Book of Kells.

Stretch these letters to fill the end of a line, elaborate one for an initial, OR just fiddle in a spirit of experimentation.

30°

A B C D E F G H I
J K L M N U O O P Q
S T U V Y W X Y Z

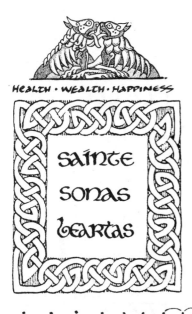

HEALTH · WEALTH · HAPPINESS

sainte
sonas
beartas

Stage 3

Wish SOMEONE a HAPPY St
Patrick's day WITH aN IRISH
GREETING, CELTIC LETTERS, &
a BIT OF DECORATIVE BORDER
FROM THE BOOK OF KELLS, aLL
HELD TOGETHER WITH a COLOR
SCHEME OF GREEN aND GOLD.

| This may be the method of the Pictist artist. | Arch one space above and below. | Break and rejoin in various ways. | Form band | Remove centre line | Interlace, over and under, alternately. |

Use India Ink or waterproof marker to draw the border so that the filled-in color won't make the outline run. The borders here are from Celtic Art: The Methods of Construction by George Bain (Dover).

when you make placecards for a large dinner or one where people may not be sure of each others' names, help them out; letter the names twice, on back and front of the card, so others can see name instead of asking—or wondering!

east side

This idiosyncratic alphabet combines several distinctive letter bodies and serifs. Use ∫ with Eastern Capitals (below).

Basic strokes

o a c g q d u y n h m p b w
Round letters Arched letters

v z u x z ε ɾ k i t l f j
Diagonal letters Individual letters Straight letters

EASTERN CAPITALS

Based on a typeface called Park Avenue; use them, sparingly, with East Side small letters (above).

Basic strokes Modify basic stroke with pen pressure

ABCDEFGHIJKLM
NOPQRSTUVWXYZ

vivaldi

An elegant variation on Basic Italic (page 36).
Based on a typeface. Use with Vivaldi Caps (be-low).

Basic strokes
Use corner of pen to make thin line.

agu & flkjit ceod
"A-body" letters Straight let-ters Round letters

bhmnpr svwyzx
"B-body" letters Diagonal letters

VIVALDI caps

Based on the typeface, this style provides ornate, decorative, easy
capitals. Use them sparingly, with Basic Italic small letters
(page 36), not grouped together in whole words as in title here.

Basic strokes
Look for similar strokes in pairs
and groups of letters.

ABCDEFGHIJKLM
NOPQRSTUVWXYZ

SPLIT ITALIC CAPS

Use with Split Italic (page 56). Avoid color-
ing it in, as corner joins are notched.

Basic strokes Corner joins

ILEFHT DBPRUJS
Straight letters Half-round letters, closed.....open

OCGQE NAXVYZWMK
Round letters Diagonal letters

light italic

A graceful, elegant style with
visual impact, at a distance or en masse.

Letter slant Basic letter body

acdegquyf iltkj
"A-body" letters Straight letters

bhmnpr os wxvz
"B-body" letters Curved letters Diagonal letters

swash italic

Existing strokes are extended or extra ones added to form swashes.

Some basic strokes

acdeguyf iljtk

"A-body" letters Straight letters

bhmnpr osvwxz

"B-body" letters Diagonal letters

gothic softlight

Fill with water-soluble solid color up to this level. Then, using clean water, dilute the color & brush it upward.

Basic strokes Invert page to simplify fill-in.

nuvhkymw ss

Open-top or -bottom letters Alternate s

ogbqpd cera tayjlf x zz

Closed letters Open-side letters 1-stroke letters Extra x Alternate z

backward italic

Based on a 16th-century Italian style by Tagli-ente, this whimsical style has great shock value.

Basic letter bodies

acdeu oqg kliitf

"A-body" letters Round letters straight letters

bhmnpr swxyzv

"B-body" letters Diagonal letters

extra-lean italic

This alphabet adds useful emphasis.

The pen's path Letterslant Basic letter bodies

acdeguyf vwxzk

"A-body" letters Diagonal letters

bhmnpr osk ltij

"B-body" letters Rounded letters Extra k 1-stroke letters

YEOMAN

Vary this alphabet in use by omitting
swashes on some letters, gaps on others.

Basic strokes Stroke order One pen width

LLEF OCGQ NAVXYZ

Straight narrow letters Round letters Diagonal letters

DBPR HTUK MW SS

Half-round letters Medium straight letters Wide diagonal letters

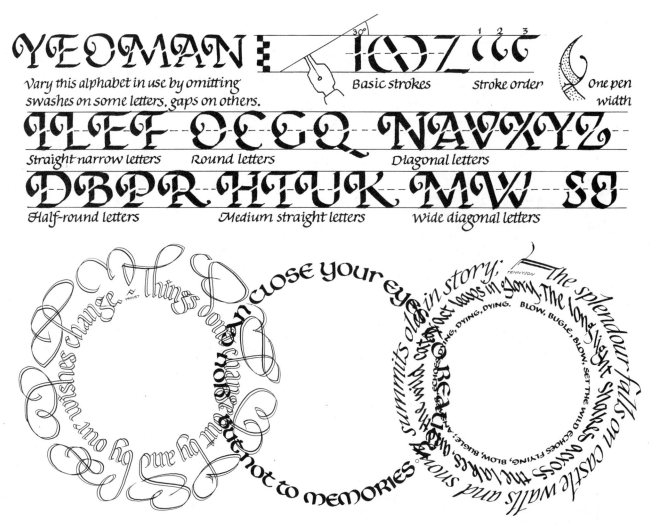

lettering in a circle; an appealing layout that challenges both
calligrapher and reader. Three approaches are shown here, over-
lapped to save space; split in two for easier legibility, swashed
for decorativeness, and slanted for abstract visual impact. Use
compass, protracter, circle template, & straightedge for guidelines.

TURNED CELTIC

Change the pen angle while you write
to widen or narrow the stroke, shape
its ends, and join it to other strokes.

Wide-narrow-wide Wide-narrow Narrow-wide Narrow-wide

Basic strokes Narrow

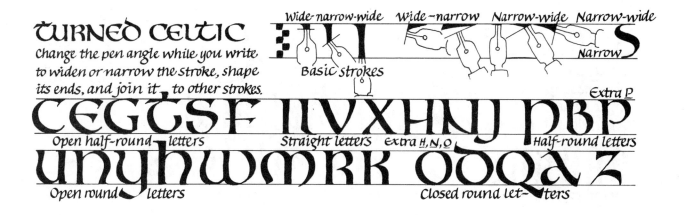

CEGTSF IIVXHNJ DBP

Open half-round letters Straight letters Extra H, N, O Half-round letters Extra P

UNYHWMRK ODGQZ

Open round letters Closed round letters

use a punctuation mark instead of a letter, to put your point across with extra punch and humor on April Fools Day.

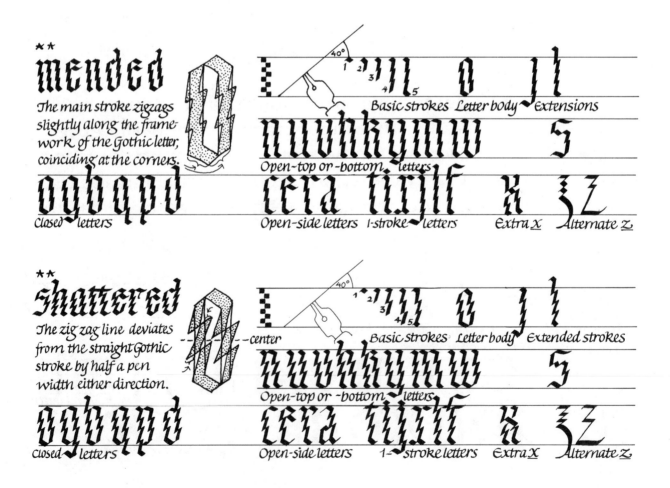

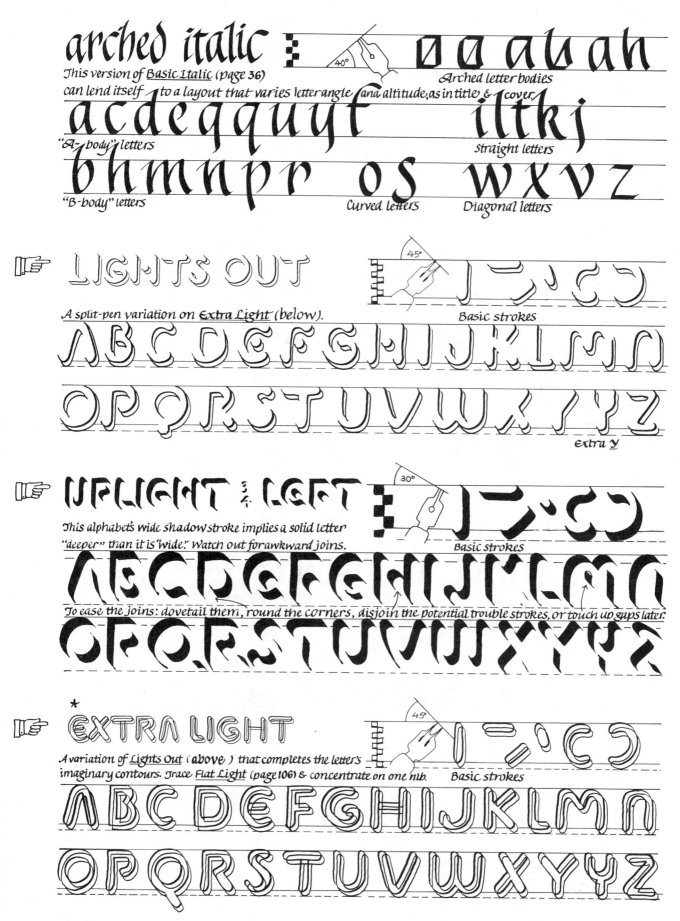

arched italic

This version of Basic Italic (page 36) can lend itself to a layout that varies letter angle and altitude, as in title & cover.

Arched letter bodies

acdeqquyf
"A-body" letters

iltkj
straight letters

bhmnpr
"B-body" letters

os
Curved letters

wxvz
Diagonal letters

☞ LIGHTS OUT

A split-pen variation on Extra Light (below).

Basic strokes

ABCDEFGHIJKLMN
OPQRSTUVWXYZ
extra y

☞ UPLIGHT ¾ LEFT

This alphabet's wide shadow stroke implies a solid letter "deeper" than it is "wide." Watch out for awkward joins.

Basic strokes

ABCDEFGHIJKLMN

To ease the joins: dovetail them, round the corners, disjoin the potential trouble strokes, or touch up gaps later.

OPQRSTUVWXYZ

☞ * EXTRA LIGHT

A variation of Lights Out (above) that completes the letter's imaginary contours. Trace Flat Light (page 106) & concentrate on one nib.

Basic strokes

ABCDEFGHIJKLMN
OPQRSTUVWXYZ

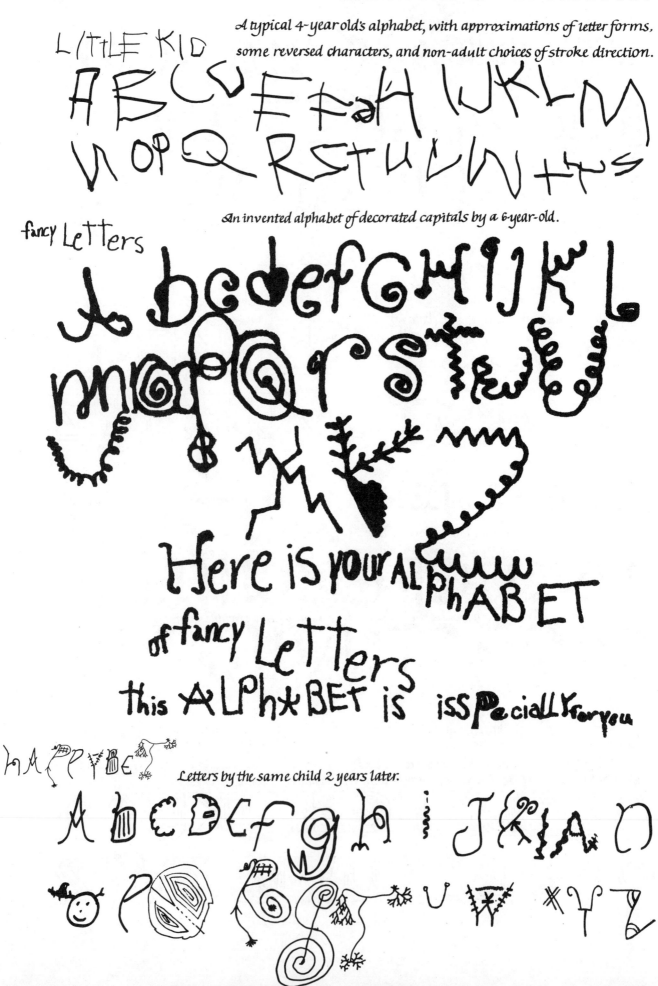

A typical 4-year old's alphabet, with approximations of letter forms, some reversed characters, and non-adult choices of stroke direction.

LITTLE KID

ABCDEFGH IJKLM NOPQ RSTUVW HS

An invented alphabet of decorated capitals by a 6-year-old.

fancy Letters

A b c d e f G H I J K L m n o p q r s t u v

Here is your ALPhABET of fancy Letters this ALPhABET is isspecially for you

HAPPYBE

Letters by the same child 2 years later.

A B C D E F g h I J K L M N O P Q R S T U V W X Y Z

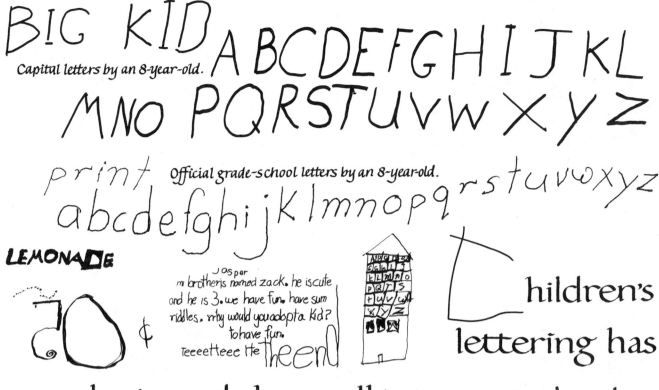

BIG KID

Capital letters by an 8-year-old.

A B C D E F G H I J K L
M N O P Q R S T U V W X Y Z

print Official grade-school letters by an 8-year-old.

a b c d e f g h i j k l m n o p q r s t u v w x y z

LEMONADE

Jasper

mi brother is named zack. he is cute and he is 3. we have fun. have sum riddles. why would you adopt a kid? to have fun.
Teeeetteee tte theend

Children's lettering has

a logic and charm all its own. Its hard to

improve on and harder still to imitate. If

you want to write like a child, construct

each letter in reverse, to see it anew. (Use

kids' materials: crayons, newsprint, scissors,

paste, construction paper, poster paints.)

☞ *palmer*

Remember those loops? Write elegant
Copperplate (page 86) with a monoline pen, and what you get is plain everyday *Palmer*.

O O
Basic strokes

o a c e r s x z j g y q p f
Round letters Individual letters Descenders: j... j g y... Round...& straight

b l h k t d i m n u v w
Ascenders: Round and straight Arched letters

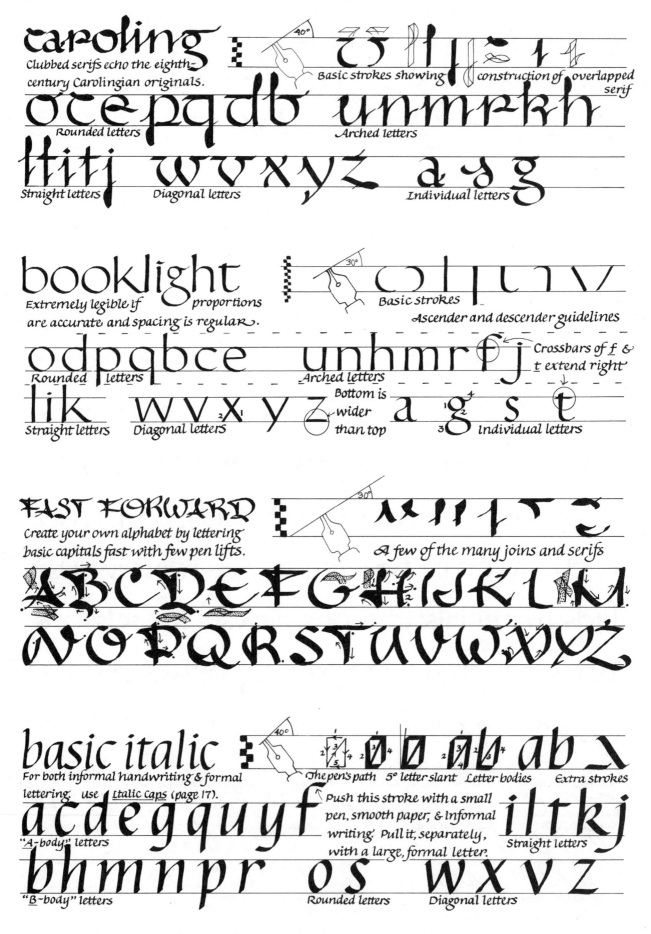

caroling
Clubbed serifs echo the eighth-century Carolingian originals.

Basic strokes showing construction of overlapped serif

Rounded letters Arched letters

Straight letters Diagonal letters Individual letters

booklight
Extremely legible if proportions are accurate and spacing is regular.

Basic strokes

Ascender and descender guidelines

Rounded letters Arched letters Crossbars of *f* & *t* extend right

Straight letters Diagonal letters Bottom is wider than top Individual letters

FAST FORWARD
Create your own alphabet by lettering basic capitals fast with few pen lifts.

A few of the many joins and serifs

ABCDEFGHIJKLM
NOPQRSTUVWXYZ

basic italic
For both informal handwriting & formal lettering. use *Italic Caps* (page 17).

The pen's path 5° letter slant Letter bodies Extra strokes

Push this stroke with a small pen, smooth paper, & informal writing. Pull it, separately, with a large, formal letter.

"A-body" letters Straight letters

"B-body" letters Rounded letters Diagonal letters

Lettering a long piece of text? Not 10 lines long. 10 _hours_ long; a memorial book, a mammoth one-page declaration in small print, an ambitious artistic project of great visual complexity and scale. In any case, you must train, warm up, and pace yourself for it. Choose your equipment carefully, to preclude glaring discontinuities. Wiggle your fingers — and your back — every 15 minutes. Above all, check and recheck constantly to guard against the disastrous hidden error that could render all your work in vain: the single mis-ruled guide-line; the omitted or repeated phrase; the wet pen dropped on the next-to-last line. Take courage from other long-distance artists toiling along the Boston Marathon on Patriots Day this week.

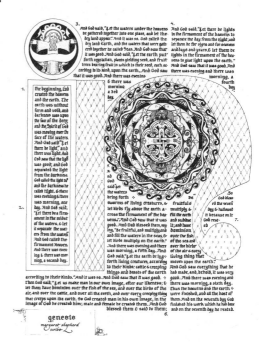

fine italian hand

Practice this large & slow, for understanding; then small & fast, for fluency & individuality.

This curve appears at bottom only of _a, d, e, u, h, m, n, l, t, & i._

a c d e g q u y f w v x z k

"A~body" letters

Diagonal letters

b h m n p r k o s l t i j

"B~body" letters

Curved letters

rough draft

Based on <u>Bookhand</u> (page 74).

This pencilled alphabet results when you sketch letters quickly to see how the words of your chosen text will fit your layout. The important thing is that the rough letters occupy exactly the same amount of space as the intended final ones.

a b c d e f g h i j k l m
n o p q r s t u v i u x y z

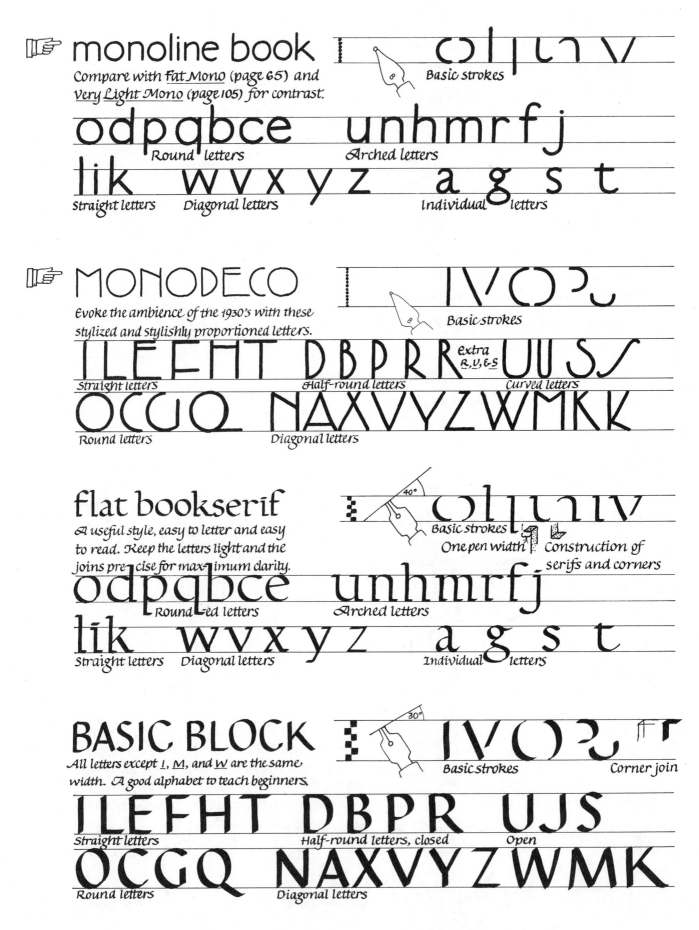

☞ monoline book

Compare with *Fat Mono* (page 65) and *Very Light Mono* (page 105) for contrast.

Basic strokes

odpqbce unhmrfj

Round letters *Arched letters*

lik wvxyz a g s t

Straight letters *Diagonal letters* *Individual letters*

☞ MONODECO

Evoke the ambience of the 1930's with these stylized and stylishly proportioned letters.

Basic strokes

ILEFHT DBPRR *extra R,V,&S* UUSS

Straight letters *Half-round letters* *Curved letters*

OCGQ NAXVYZWMKK

Round letters *Diagonal letters*

flat bookserif

A useful style, easy to letter and easy to read. Keep the letters light and the joins precise for maximum clarity.

40° Basic strokes One pen width Construction of serifs and corners

odpqbce unhmrfj

Rounded letters *Arched letters*

lik wvxyz a g s t

Straight letters *Diagonal letters* *Individual letters*

BASIC BLOCK

All letters except I, M, and W are the same width. A good alphabet to teach beginners.

30° Basic strokes Corner join

ILEFHT DBPR UJS

Straight letters *Half-round letters, closed* *Open*

OCGQ NAXVYZWMK

Round letters *Diagonal letters*

monoline serif

An informal, hard-working style.
Easy to read at various distances.

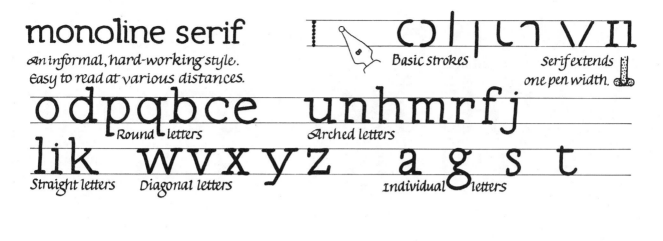

Basic strokes

Serif extends
one pen width.

odpqbce unhmrfj

Round letters Arched letters

lik wvxyz a g s t

Straight letters Diagonal letters Individual letters

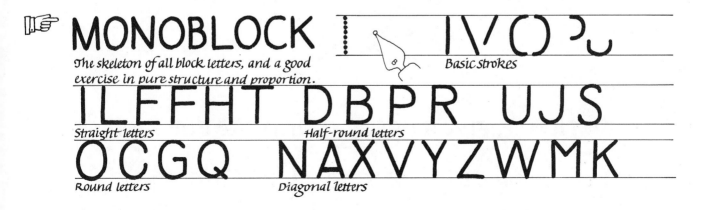

some calligraphy projects demand that you consider legibility above all else. A name tag will be almost useless if people can not read it at a glance while shaking hands. Remember, as you choose a letter style for name tags, that lightweight, unusual, or ornate alphabets make names harder to read, and that words in all-capitals are less legible than the usual capitals and small letters.

☞ MONOBLOCK

The skeleton of all block letters, and a good
exercise in pure structure and proportion.

Basic strokes

ILEFHT DBPR UJS

Straight letters Half-round letters

OCGQ NAXVYZWMK

Round letters Diagonal letters

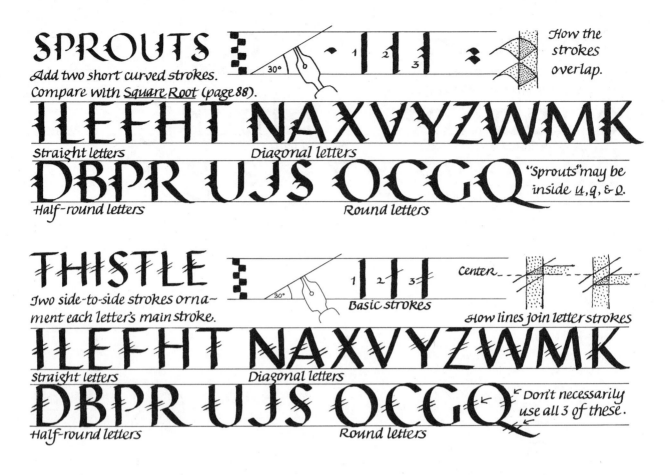

SPROUTS

Add two short curved strokes.
Compare with *Square Root* (page 88).

How the strokes overlap.

30°

1 2 3

ILEFHT NAXVYZWMK

Straight letters Diagonal letters

DBPR UJS OCGQ

Half-round letters Round letters

"Sprouts" may be inside u, q, & Q.

THISTLE

Two side-to-side strokes orna-
ment each letter's main stroke.

30°

1 2 3

Basic strokes

Center

How lines join letter strokes

ILEFHT NAXVYZWMK

Straight letters Diagonal letters

DBPR UJS OCGQ

Half-round letters Round letters

Don't necessarily use all 3 of these.

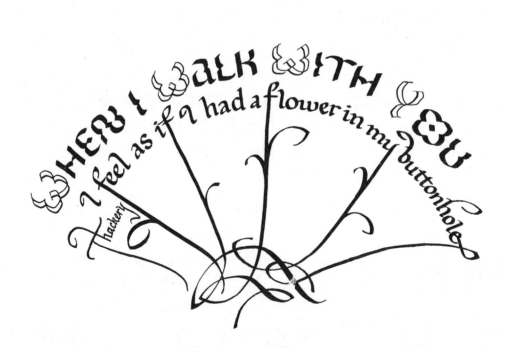

WHEN I WALK WITH YOU

I feel as if I had a flower in my buttonhole

— Thackeray

wear a flower, give a nosegay, or write out a whole

bouquet to celebrate *May Day*.

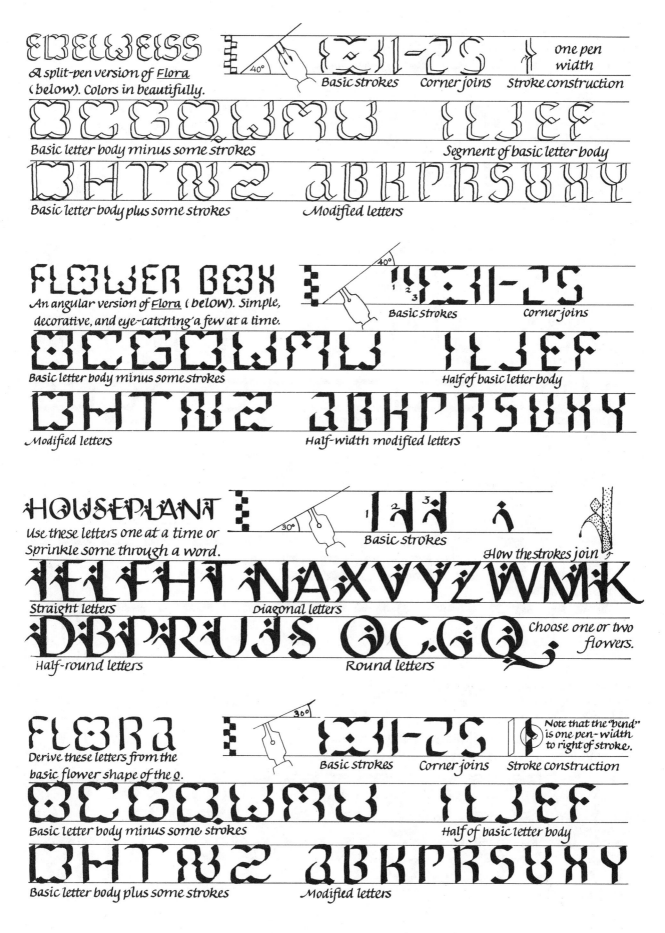

EDELWEISS

A split-pen version of *Flora* (below). Colors in beautifully.

40° | Basic strokes | Corner joins | Stroke construction | one pen width

Basic letter body minus some strokes

Segment of basic letter body

Basic letter body plus some strokes

Modified letters

FLOWER BOX

An angular version of *Flora* (below). Simple, decorative, and eye-catching a few at a time.

40° | Basic strokes | Corner joins

Basic letter body minus some strokes

Half of basic letter body

Modified letters

Half-width modified letters

HOUSEPLANT

Use these letters one at a time or sprinkle some through a word.

30° | Basic strokes | How the strokes join

Straight letters

Diagonal letters

Half-round letters

Round letters

Choose one or two flowers.

FLORA

Derive these letters from the basic flower shape of the *o*.

30° | Basic strokes | Corner joins | Stroke construction | Note that the "bend" is one pen-width to right of stroke.

Basic letter body minus some strokes

Half of basic letter body

Basic letter body plus some strokes

Modified letters

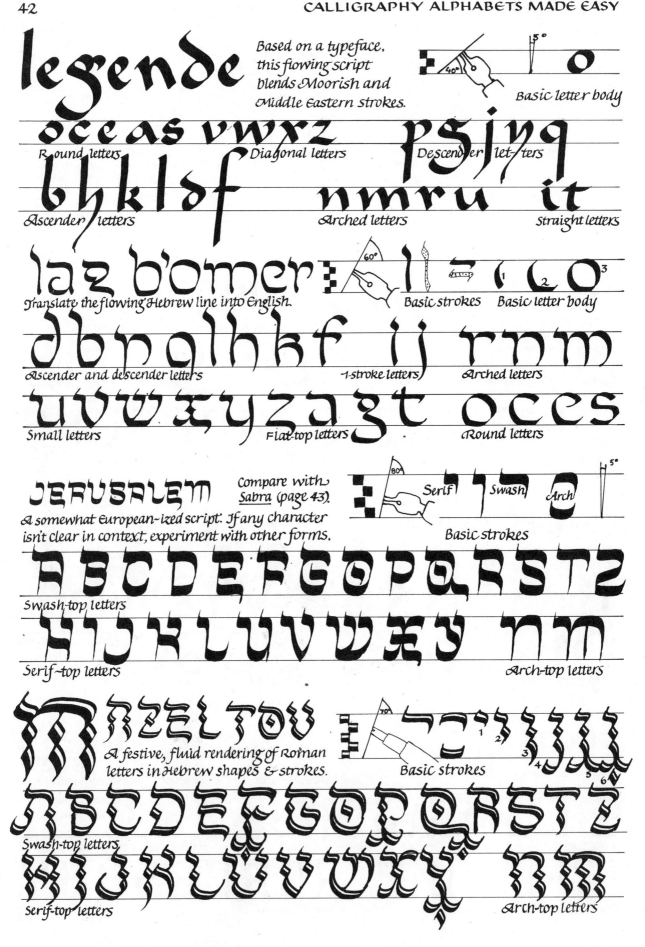

legende

Based on a typeface, this flowing script blends Moorish and Middle Eastern strokes.

Basic letter body

Round letters Diagonal letters Descender letters

Ascender letters Arched letters Straight letters

lag b'omer

Translate the flowing Hebrew line into English.

Basic strokes Basic letter body

Ascender and descender letters 1-stroke letters Arched letters

Small letters Flat-top letters Round letters

JERUSALEM

Compare with Sabra (page 43).

A somewhat European-ized script: If any character isn't clear in context, experiment with other forms.

Serif Swash Arch

Basic strokes

Swash-top letters

Serif-top letters Arch-top letters

MAZEL TOV

A festive, fluid rendering of Roman letters in Hebrew shapes & strokes.

Basic strokes

Swash-top letters

Serif-top letters Arch-top letters

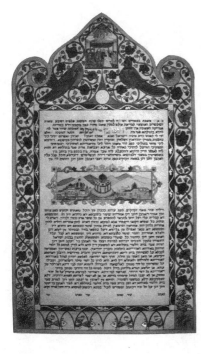

Jewish marriages were traditionally document-ed with a marriage license called a Ketubah. This certificate, now a semi~official option, can be adapted to the spirit of all religions. Its lush ornament is personalized with colors & motifs that reflect the individuality of the betrothed couple. Framed and hung over the marriage bed, it makes an incomparable wedding present and a priceless heirloom for future generations. The second week in May is Jewish Heritage Week.

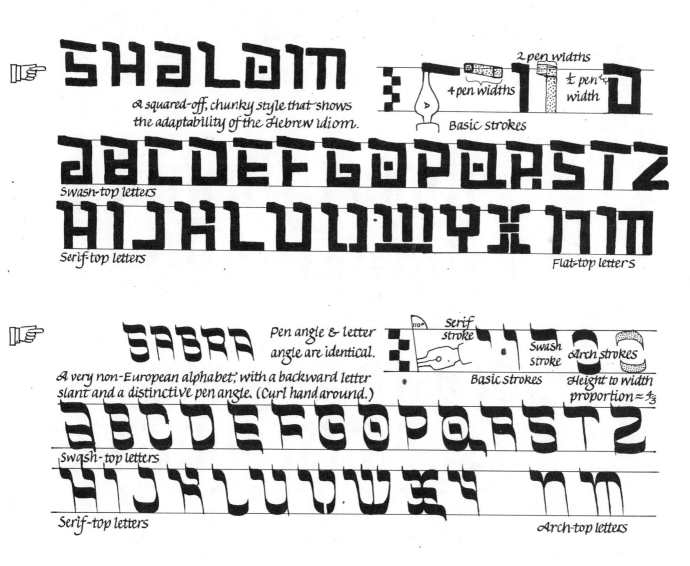

A squared-off, chunky style that shows the adaptability of the Hebrew idiom.

4 pen widths 2 pen widths ½ pen width

Basic strokes

Swash-top letters

Serif-top letters

Flat-top letters

Pen angle & letter angle are identical.

A very non-European alphabet; with a backward letter slant and a distinctive pen angle. (Curl hand around.)

Serif stroke Swash stroke Arch strokes

Basic strokes

Height to width proportion ≈ ⅓

Swash-top letters

Serif-top letters

Arch-top letters

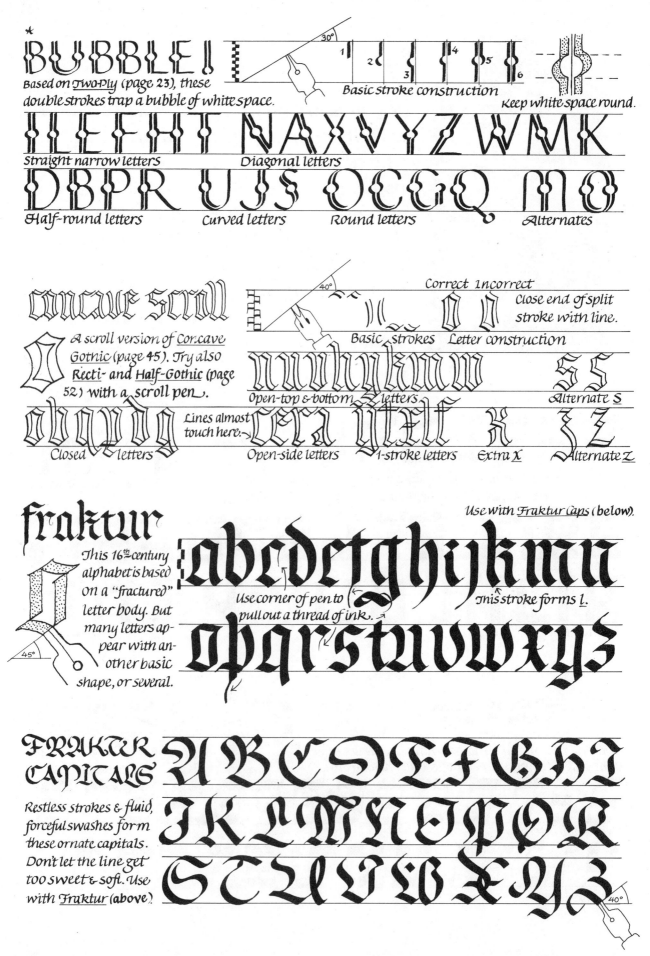

BUBBLE!

Based on _Two-Ply_ (page 23), these double strokes trap a bubble of white space.

Basic stroke construction

Keep white space round.

ILEFHT NAXVYZWMK

Straight narrow letters _Diagonal letters_

DBPR UJS OCGQ MO

Half-round letters _Curved letters_ _Round letters_ _Alternates_

CONCAVE SCROLL

A scroll version of _Concave Gothic_ (page 45). Try also _Recti-_ and _Half-Gothic_ (page 52) with a scroll pen.

Lines almost touch here:

Closed letters

Correct Incorrect

Close end of split stroke with line.

Basic strokes Letter construction

Open-top & bottom letters _Alternate S_

Open-side letters _1-stroke letters_ _Extra X_ _Alternate Z_

fraktur

This 16th century alphabet is based on a "fractured" letter body. But many letters appear with another basic shape, or several.

Use with _Fraktur Caps_ (below).

abcdetghijkmn

Use corner of pen to pull out a thread of ink.

This stroke forms _l._

opqrstuvwxyz

FRAKTUR CAPITALS

Restless strokes & fluid, forceful swashes form these ornate capitals. Don't let the line get too sweet & soft. Use with _Fraktur_ (above).

ABCDEFGHI

JKLMNOPQR

STUVWXYZ

concave gothic

A 'collapsed' version of Basic Gothic (page 20). Be careful; it can look fake-antique if curve is exaggerated.

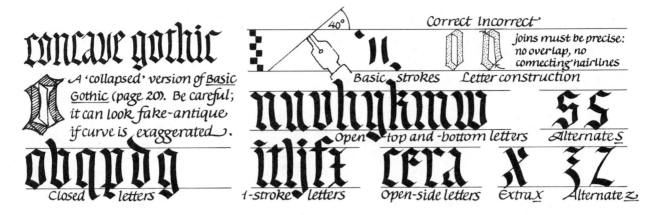

40°

Correct Incorrect — joins must be precise: no overlap, no connecting hairlines

Basic strokes Letter construction

nuvhykmw ss

Open-top and -bottom letters *Alternate s*

itljfi cera x zz

Closed letters *1-stroke letters* *Open-side letters* *Extra x* *Alternate z*

obqpdg

Born July 2, 1986 — 7 pounds, 2 ounces
Fresno, California — 18 inches

Sarah Ellen Pfeiffer

✿ daughter of ✿

Maria Delaney Pheiffer
James Ray Pheiffer

Did you know that babies born in May are on the average 200 grams (¼ pound) heavier than those born in other months? Celebrate any new arrival with a 'Fraktur', the folk-art birth certificate originated by 19th-century Pennsylvania Dutch. Include name, parents, date, and place, and decorate with naive flowers, quaint people, and ornamental pen flourishes.

half- round gothic

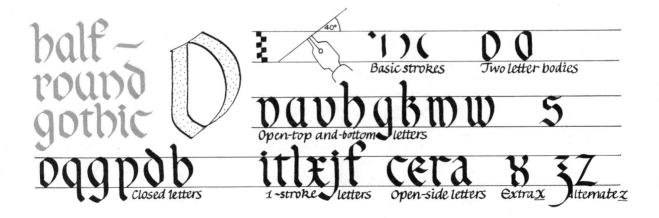

40°

Basic strokes Two letter bodies

vavhgkmw s

Open-top and -bottom letters

oqgpdb

Closed letters

itlxjf cera x zz

1-stroke letters *Open-side letters* *Extra x* *Alternate z*

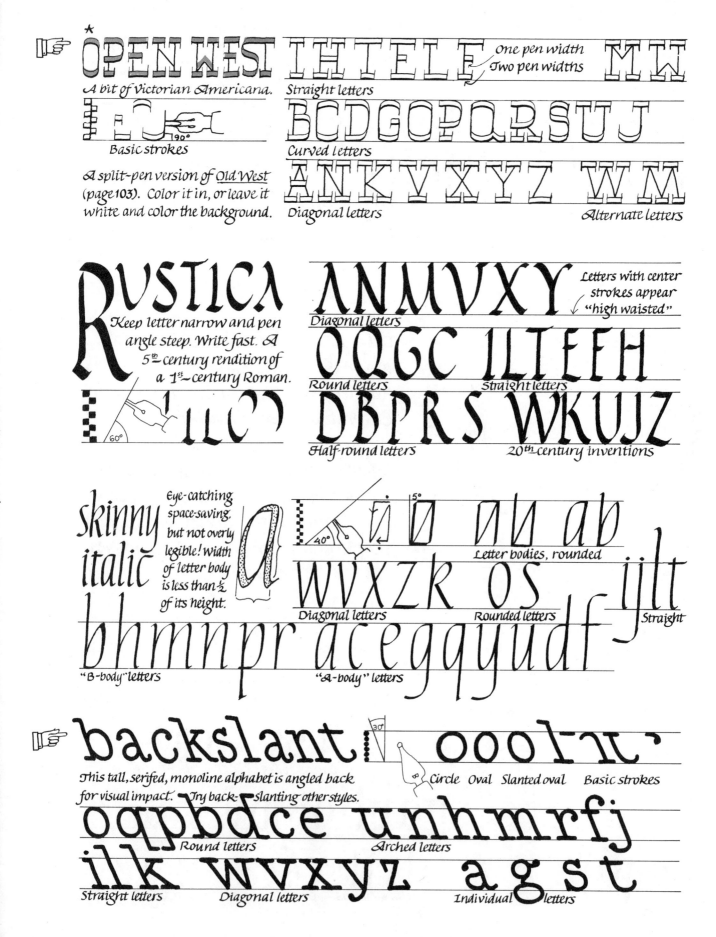

☞ **OPEN WEST**

A bit of Victorian Americana.

Basic strokes 190°

A split-pen version of Old West (page 103). Color it in, or leave it white and color the background.

IHTELF One pen width Two pen widths IHIW

Straight letters

BCDGOPQRSUJ

Curved letters

ANKVXYZ WM

Diagonal letters *Alternate letters*

RVSTICA

Keep letter narrow and pen angle steep. Write fast. A 5th century rendition of a 1st-century Roman.

60°

ANMVXY *Letters with center strokes appear "high waisted"*

Diagonal letters

OQGC ILTEEH

Round letters *Straight letters*

DBPRS WKUJZ

Half-round letters *20th century inventions*

skinny italic

Eye-catching, space-saving, but not overly legible! width of letter body is less than ½ of its height.

40° 5°

a b

Letter bodies, rounded

WVXZK OS ijlt

Diagonal letters *Rounded letters* *Straight*

bhmnpr acegqyudf

"B-body" letters *"A-body" letters*

☞ **backslant**

This tall, serifed, monoline alphabet is angled back for visual impact. Try back-slanting other styles.

30°

ooolrr

Circle Oval Slanted oval Basic strokes

oqpbdce unhmrfj

Round letters *Arched letters*

ilk wvxyz agst

Straight letters *Diagonal letters* *Individual letters*

chancellaresca This alphabet, based on a type face, is a combination of Copperplate and Italic, with nar- row pen & steep slant.

oace szæi gjpqy
Round letters Individual letters Four differ- ent descenders 30°

bdhklfſt mnuvwr
30°
Ascenders Arched letters

carpetbags oljjuvog
This alphabet manages to harmonize half a 30° Ascenders are 3 times the Practice joining this
dozen families, ascenders & descenders of letter body height; descenders letter body smoothly
different heights, and other minor quirks. are shorter than one. to the straight stem.

unyhm apdbqg
Arched letters Tear- drop letters

lfkji oce wvxz trs
Straight letters Round letters Diagonal letters Individual letters

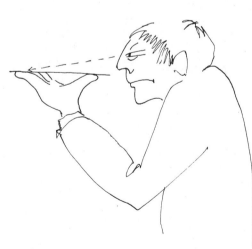

May is 'Correct Posture Month.' Help your letters all maintain one letter angle, as almost every alphabet style* relies on a uniform letter angle. Your eye will usually detect the one odd drunk in a crowd of teetotalers; it's the gradually-leaning row of degenerates — or the ones pitched at the wrong angle to start with — that sneak past you to disorient the viewer. Some precautions against wry angles: rule occasional pencilled verticals (or near-verticals) in addition to horizontal guidelines, for a visual reminder. Reorient your body and hand to the paper to help your eye maintain a constant letter angle. To check uniformity, hold paper on palms, almost edgewise to your eyes, and squint.

*But see y-Chromosome and Arched Italic. (pages 49 and 33)

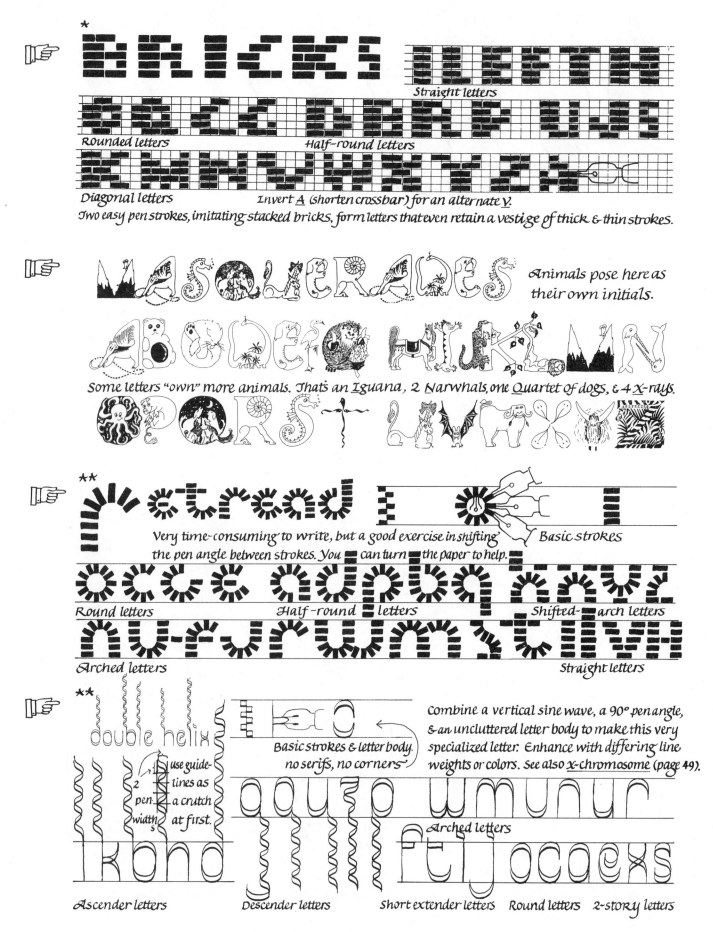

BRICKS

Straight letters

Rounded letters

Half-round letters

Diagonal letters

Invert A (shorten crossbar) for an alternate V.

Two easy pen strokes, imitating stacked bricks, form letters that even retain a vestige of thick & thin strokes.

MASQUERADES

Animals pose here as their own initials.

Some letters "own" more animals. That's an Iguana, 2 Narwhals, one Quartet of dogs, & 4 X-rays.

** **Retread**

Very time-consuming to write, but a good exercise in shifting the pen angle between strokes. You can turn the paper to help.

Basic strokes

Round letters

Half-round letters

Shifted-arch letters

Arched letters

Straight letters

** double helix

use guide-lines as a crutch at first. 2 pen widths

Basic strokes & letter body. no serifs, no corners

Combine a vertical sine wave, a 90° pen angle, & an uncluttered letter body to make this very specialized letter. Enhance with differing line weights or colors. See also x-chromosome (page 49).

Arched letters

Ascender letters

Descender letters

Short extender letters

Round letters

2-story letters

X-CHROMOSOME

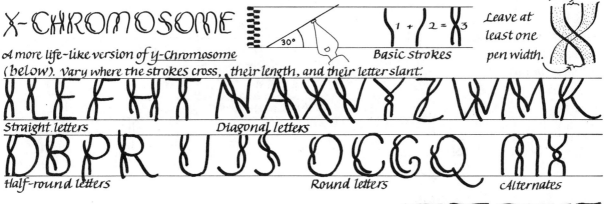

A more life-like version of Y-Chromosome (below). Vary where the strokes cross, their length, and their letter slant.

30° Basic strokes Leave at least one pen width.

XLEFHT NAXVYZWMK

Straight letters *Diagonal letters*

DBPR UJS OCGQ MX

Half-round letters *Round letters* *Alternates*

Medieval bestiaries collected real and mythical animals, and ornamental beasts filled illuminated manuscripts.

During National Zoo Month, use animals and real objects to decorate, inhabit, or impersonate the letters of the alphabet.

Y-CHROMOSOME

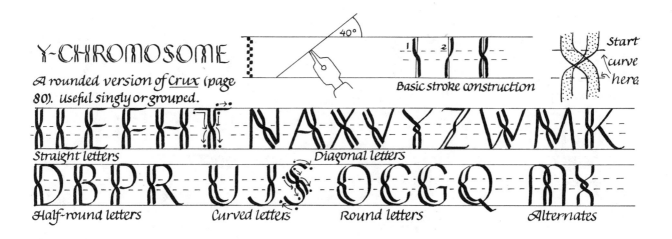

A rounded version of Crux (page 80). Useful singly or grouped.

40° Basic stroke construction Start curve here

XLEFHT NAXVYZWMK

Straight letters *Diagonal letters*

DBPR UJS OCGQ MX

Half-round letters *Curved letters* *Round letters* *Alternates*

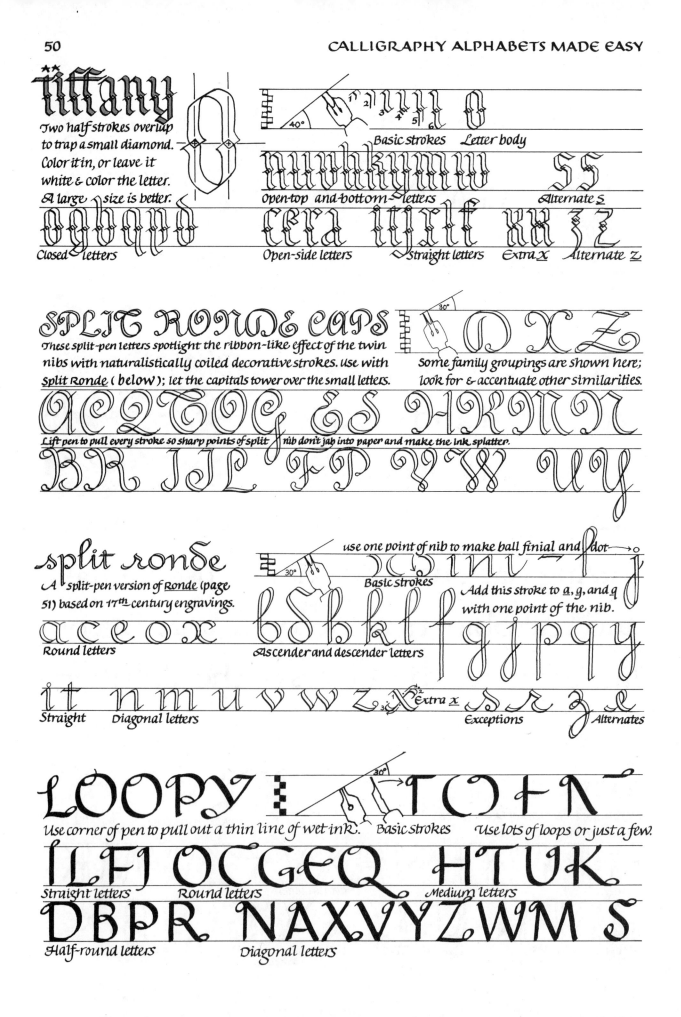

tiffany

Two half strokes overlap to trap a small diamond. Color it in, or leave it white & color the letter. A large size is better.

Basic strokes Letter body

Open-top and bottom letters Alternate *s*

Closed letters Open-side letters Straight letters Extra *x* Alternate *z*

SPLIT RONDE CAPS

These split-pen letters spotlight the ribbon-like effect of the twin nibs with naturalistically coiled decorative strokes. Use with Split Ronde (below); let the capitals tower over the small letters.

Some family groupings are shown here; look for & accentuate other similarities.

Lift pen to pull every stroke so sharp points of split nib don't jab into paper and make the ink splatter.

split ronde

A split-pen version of Ronde (page 51) based on 17th century engravings.

use one point of nib to make ball finial and dot

Basic strokes

Add this stroke to *a*, *g*, and *q* with one point of the nib.

Round letters Ascender and descender letters

Straight Diagonal letters Extra *x* Exceptions Alternates

LOOPY

Use corner of pen to pull out a thin line of wet ink. Basic strokes Use lots of loops or just a few.

Straight letters Round letters Medium letters

Half-round letters Diagonal letters

Save your prettiest, most grac[e]... lettering for the formal invitation to a June wedding (even though more couples, in fact, marry in the month of December!). A few—less than three—simple swashes add warmth without detracting from the effect of elegance, solemnity, and joy.

Cathie Dobson and Jake Wheeler
would like you to join family and friends
for their wedding
Saturday the second of June at three o'clock
Milton Academy Chapel
Milton, Massachusetts

and for a reception
at the home of her parents

R.S.V.P.

Mr. and Mrs. John Gordon Dobson
118 Needham Avenue
Dedham, Massachusetts. 02026

ronde

This 17th century style lends delicacy
& elegance to texts or single lines.

Basic strokes

a c e o x

Round letters Spread out letter
spacing for legibility and beauty

Ascender and descender letters
Allow more vertical space than can be shown here.

Alternate z and e

i t n m u v w z x Alternate x s r z e

Straight Diagonal letters Exceptions

SPLIT SWASH OVERLAP

Allow some of this alphabet's swashes to cross each other, or try weaving them over and under each other by lifting the pen in midstroke and touching up the gap later.

Basic strokes cross weave

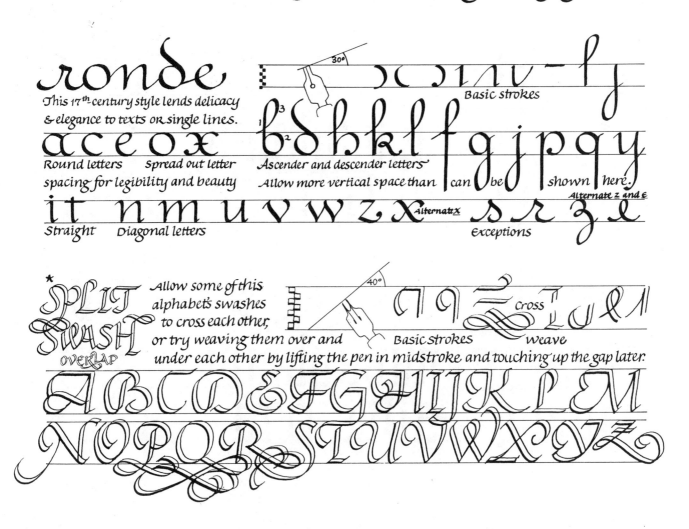

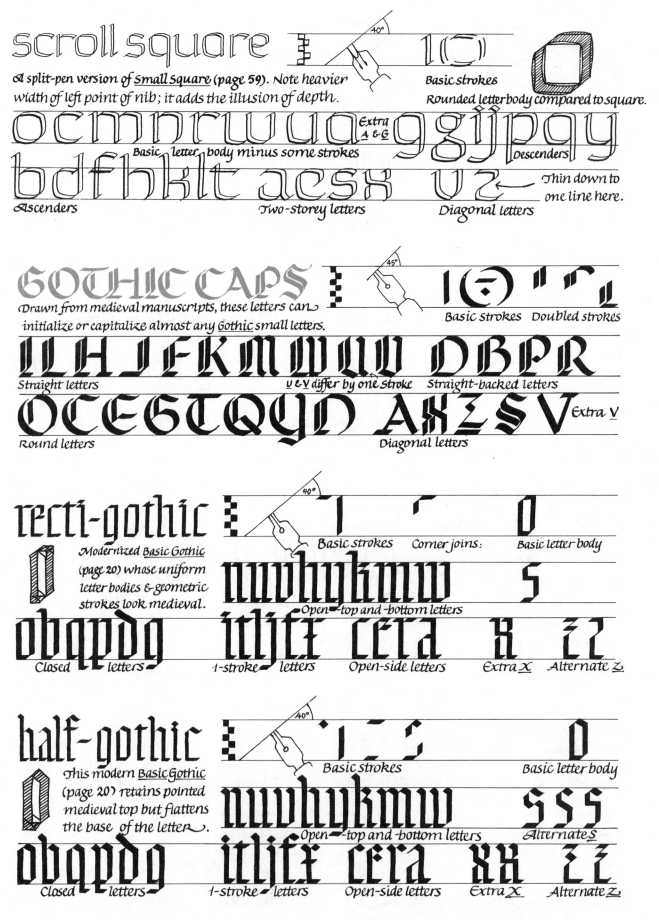

scroll square

A split-pen version of Small Square (page 59). Note heavier width of left point of nib; it adds the illusion of depth.

Basic strokes

Rounded letterbody compared to square.

ocmnrwua *Extra A & G* ggijpqy

Basic letter body minus some strokes Descenders

bdfhklt aesx vz — Thin down to one line here.

Ascenders Two-storey letters Diagonal letters

GOTHIC CAPS

Drawn from medieval manuscripts, these letters can initialize or capitalize almost any Gothic small letters.

Basic Strokes Doubled strokes

ILHJFKMWW DBPR

Straight letters U & V differ by one stroke Straight-backed letters

OCEGTQYD AXZV *Extra V*

Round letters Diagonal letters

recti-gothic

Modernized Basic Gothic (page 20) whose uniform letter bodies & geometric strokes look medieval.

Basic strokes Corner joins: Basic letter body

nuvhykmw s

Open-top and -bottom letters

obqpdg itljfx cera x zz

Closed letters 1-stroke letters Open-side letters Extra X Alternate Z

half-gothic

This modern Basic Gothic (page 20) retains pointed medieval top but flattens the base of the letter.

Basic strokes Basic letter body

nuvhykmw sss

Open-top and -bottom letters Alternate S

obqpdg itljfx cera xx zz

Closed letters 1-stroke letters Open-side letters Extra X Alternate Z

lightgothic

A __Basic Gothic__ (page 20) with a narrow pen. Less antique-looking, a little more legible, less forceful.

closed letters obqpdg

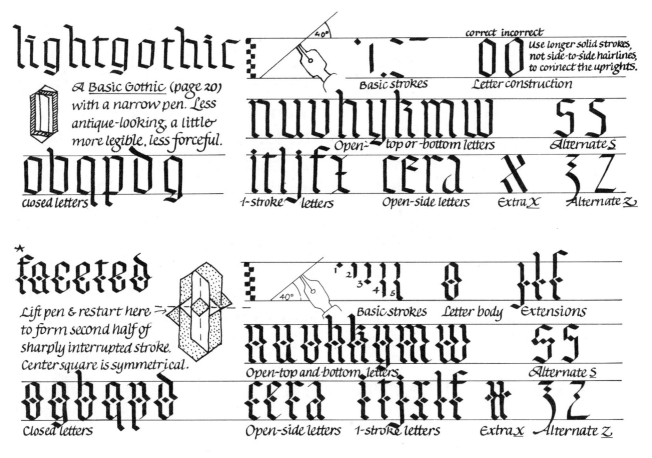

Basic strokes

correct incorrect — Use longer solid strokes, not side-to-side hairlines, to connect the uprights. — Letter construction

nuvhykmw — SS — Alternate S

Open-top or-bottom letters

itljfi cera X 3Z

1-stroke letters — Open-side letters — Extra X — Alternate Z

✦faceted

Lift pen & restart here → to form second half of sharply interrupted stroke. Center square is symmetrical.

Closed letters ogbqpd

Basic strokes — Letter body — Extensions

nuvhkymw — SS — Alternate S

Open-top and-bottom letters

cera itjxlf x 3Z

Open-side letters — 1-stroke letters — Extra X — Alternate Z

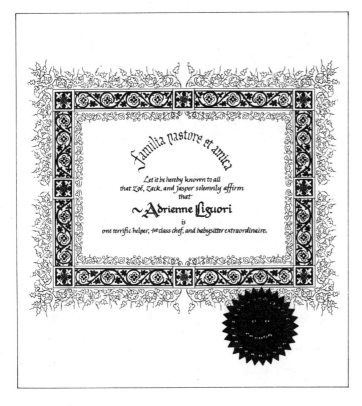

Familia pastore et amica

Let it be hereby known to all that Zoë, Zack, and Jasper solemnly affirm that

~Adrienne Liguori

is

one terrific helper, 1st class chef, and babysitter extraordinaire.

Not every diploma has to come from an institution, nor go to a graduating senior. Reward someone for everyday tenacity or extraordinary virtue with a 'diploma' of your own creation that resembles the real thing.

Miss Beverley Delouise
482 Westwood Drive
Birchville
Indiana
45102

Miss Beverley Delouise
482 Westwood Drive
Birchville
Indiana
45102

When addressing envelopes, choose from either a flat-left or a slanted-left style of layout. Plan pen size, letter size, spacing & line placement by lettering several rough drafts of the longest name and address on your list: for example, Mr. and Mrs. Francis Belmont Smithson, 13286 Columbia Point Gardens, #14R, East Hampton, Massachusetts 02345, not Gail Ely, 2 Main Street, Ames, Iowa 50123. And when you choose an alphabet, be prepared to see a lot of that capital 'M,' which initializes most of the formal titles that you will be lettering.

Mr. Mr. Mr. Mr. Mrs. Mrs. Mrs. Miss Miss

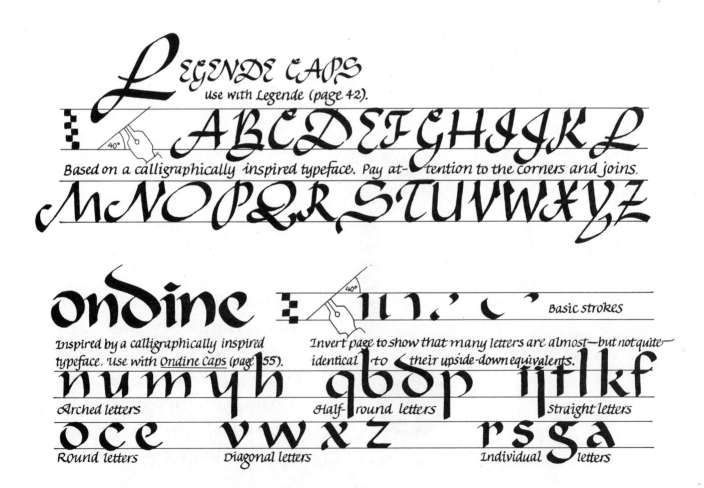

LEGENDE CAPS
Use with Legende (page 42).

40°

ABCDEFGHIJKL

Based on a calligraphically inspired typeface. Pay at-tention to the corners and joins.

MNOPQRSTUVWXYZ

ondine

40° III. ' ' Basic strokes

Inspired by a calligraphically inspired typeface. Use with Ondine Caps (page 55).

Invert page to show that many letters are almost—but not quite—identical to their upside-down equivalents.

numyh qbdp ijtlkf

Arched letters Half-round letters Straight letters

oce vwxz rsga

Round letters Diagonal letters Individual letters

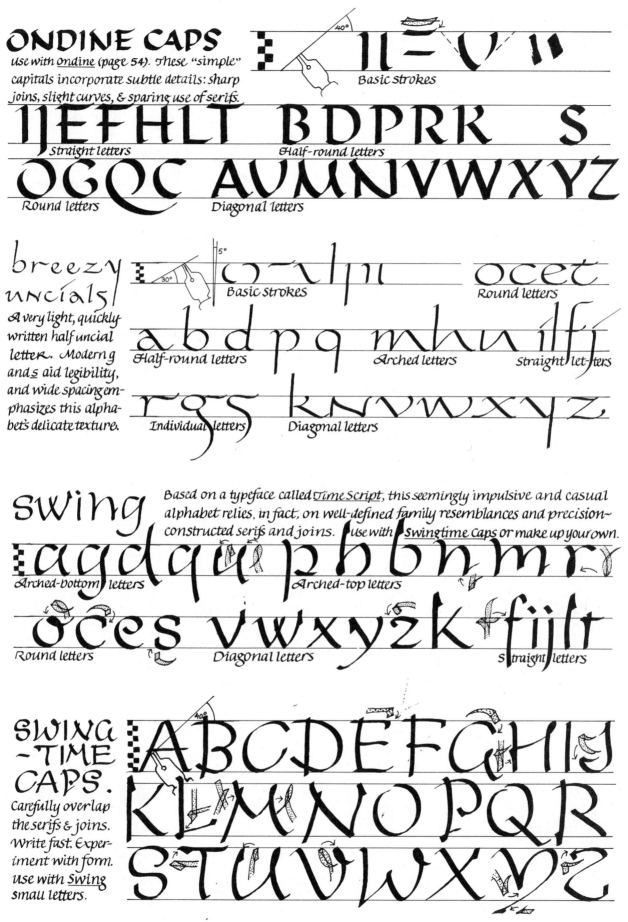

ONDINE CAPS

Use with _Ondine_ (page 54). These "simple" capitals incorporate subtle details: sharp joins, slight curves, & sparing use of serifs.

Basic strokes

IJEFHLT — Straight letters

BDPRK — Half-round letters

S

OGQC — Round letters

AVMNVWXYZ — Diagonal letters

breezy uncials

A very light, quickly written half uncial letter. Modern g and _s_ aid legibility, and wide spacing emphasizes this alphabet's delicate texture.

Basic strokes

ocet — Round letters

abdpq — Half-round letters

mhu — Arched letters

ilfj — Straight letters

rgs — Individual letters

knvwxyz — Diagonal letters

swing

Based on a typeface called _Time Script_, this seemingly impulsive and casual alphabet relies, in fact, on well-defined family resemblances and precision-constructed serifs and joins. Use with _Swingtime Caps_ or make up your own.

agdqu — Arched-bottom letters

phbnmr — Arched-top letters

oces — Round letters

vwxyzk — Diagonal letters

fijlt — Straight letters

SWING-TIME CAPS.

Carefully overlap the serifs & joins. Write fast. Experiment with form. Use with _Swing_ small letters.

ABCDEFGHIJ

KLMNOPQR

STUVWXYZ

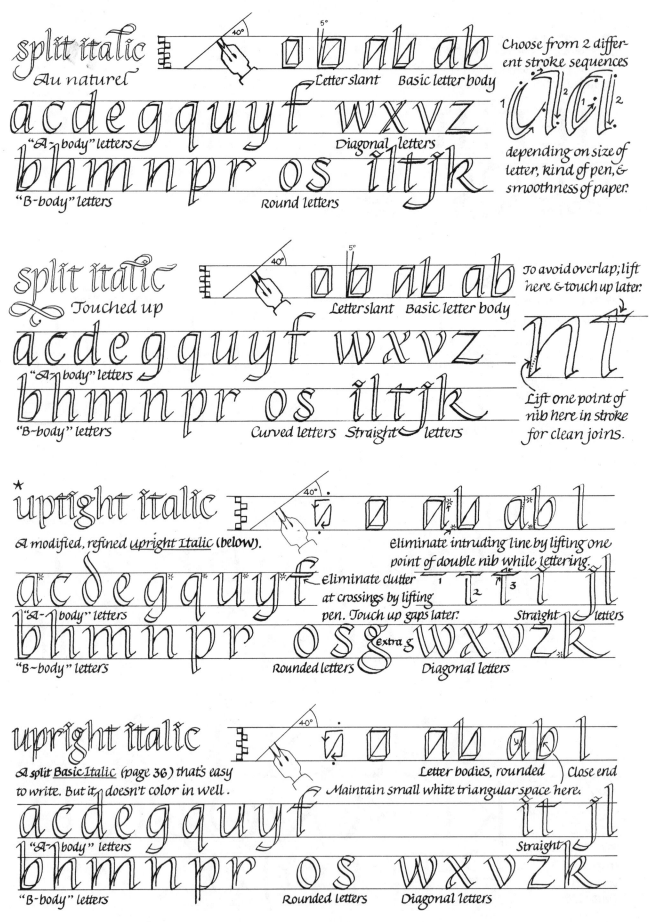

split italic
Au naturel

Letter slant Basic letter body

Choose from 2 different stroke sequences

a c d e g q u y f w x v z
"A-body" letters Diagonal letters

depending on size of letter, kind of pen, & smoothness of paper.

b h m n p r o s i l t j k
"B-body" letters Round letters

split italic
Touched up

Letter slant Basic letter body

To avoid overlap; lift here & touch up later.

a c d e g q u y f w x v z
"A-body" letters

Lift one point of nib here in stroke for clean joins.

b h m n p r o s i l t j k
"B-body" letters Curved letters Straight letters

★ **uptight italic**

A modified, refined <u>upright Italic</u> (**below**).

eliminate intruding line by lifting one point of double nib while lettering.

a c d e g q u y f
"A-body" letters

eliminate clutter at crossings by lifting pen. Touch up gaps later.

Straight letters

b h m n p r o s g w x v z k
"B-body" letters Rounded letters Extra g Diagonal letters

upright italic

A split <u>Basic Italic</u> (page 36) that's easy to write. But it doesn't color in well.

Letter bodies, rounded Close end

Maintain small white triangular space here.

a c d e g q u y f
"A-body" letters

i t j l
Straight

b h m n p r o s w x v z k
"B-body" letters Rounded letters Diagonal letters

June 30 is, along with December 31, the day when the Bureau
International de l'Heure can determine to add or subtract an
extra second to ensure that man-made clocks will coordinate
with astronomical time. A 'Leap Second' is added every year or 2.
If you think such small quantities don't really matter, watch this:
If you think such small quantities don't really matter, watch this:
just .1 mm ($\frac{3}{1000}$ inch) of space less between letters and you end
up with a noticeable gap at the margin. Think of the difference
those accumulated missing seconds might make in 1000 years!

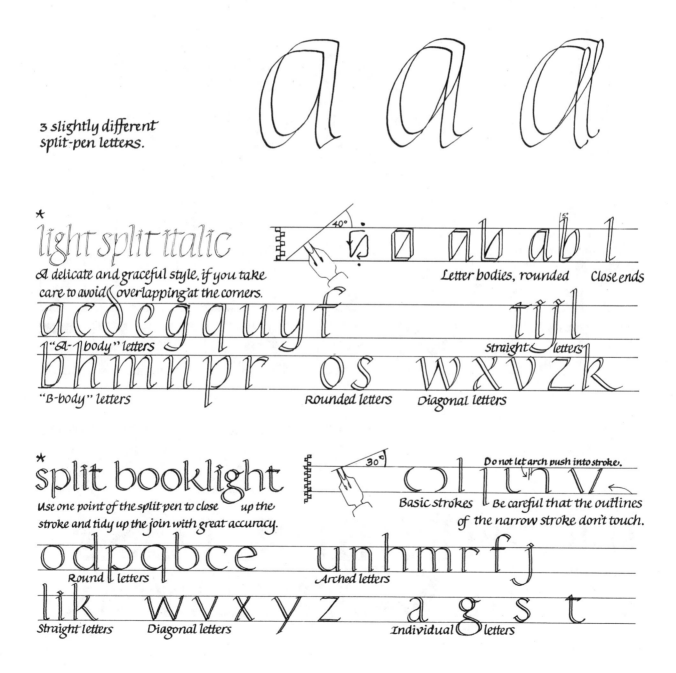

3 slightly different
split-pen letters.

light split italic

A delicate and graceful style, if you take
care to avoid overlapping at the corners.

Letter bodies, rounded Close ends

"A-1 body" letters straight letters

"B-body" letters Rounded letters Diagonal letters

split booklight

Use one point of the split pen to close up the
stroke and tidy up the join with great accuracy.

Basic strokes Be careful that the outlines
of the narrow stroke don't touch.

Do not let arch push into stroke.

Round letters Arched letters

Straight letters Diagonal letters Individual letters

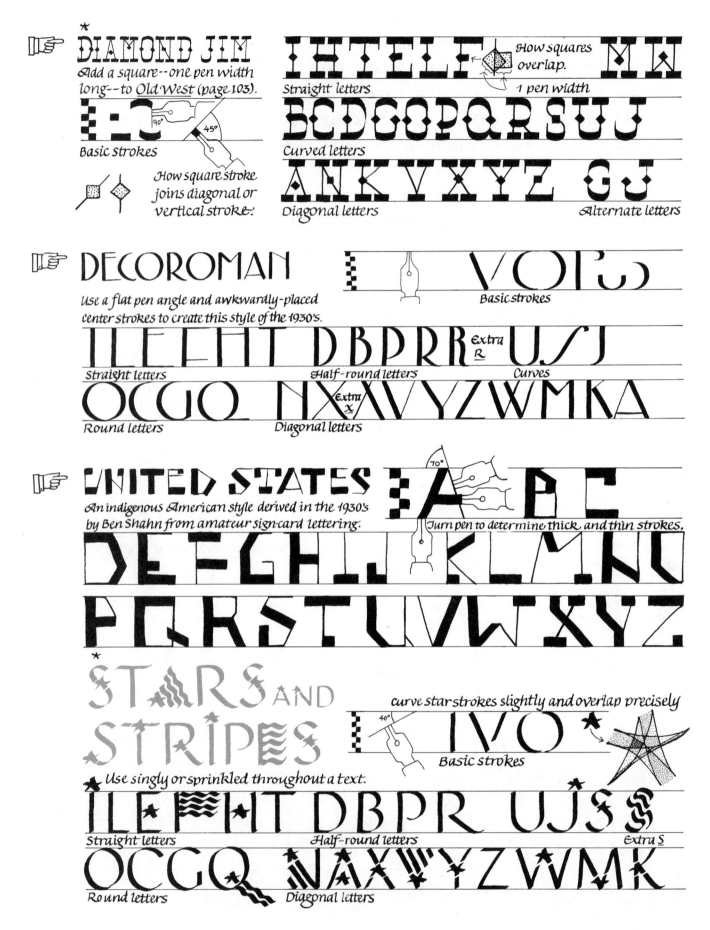

☞ **DIAMOND JIM**

Add a square--one pen width long--to *Old West* (page 103).

Basic strokes

90° 45°

How square stroke joins diagonal or vertical stroke:

How squares overlap.

1 pen width

Straight letters

Curved letters

Diagonal letters

Alternate letters

☞ **DECOROMAN**

Use a flat pen angle and awkwardly-placed center strokes to create this style of the 1930's.

Basic strokes

Straight letters Half-round letters Extra R Curves

Round letters Diagonal letters Extra X

☞ **UNITED STATES**

An indigenous American style derived in the 1930's by Ben Shahn from amateur sign-card lettering.

70°

Turn pen to determine thick and thin strokes.

STARS AND **STRIPES**

Use singly or sprinkled throughout a text.

curve star strokes slightly and overlap precisely

40°

Basic strokes

Straight letters Half-round letters Extra S

Round letters Diagonal letters

Free from English rule and far from European fashions, Americans developed their own idiom in the arts. The distinctively New World alphabets of the last hundred years are chronicaled here to show how over the years our national taste grew and changed.

Independence

INDEPENDENCE

Independence

INDEPENDENCE!

INDEPENDENCE

INDEPENDENCE

INDEPENDENCE!

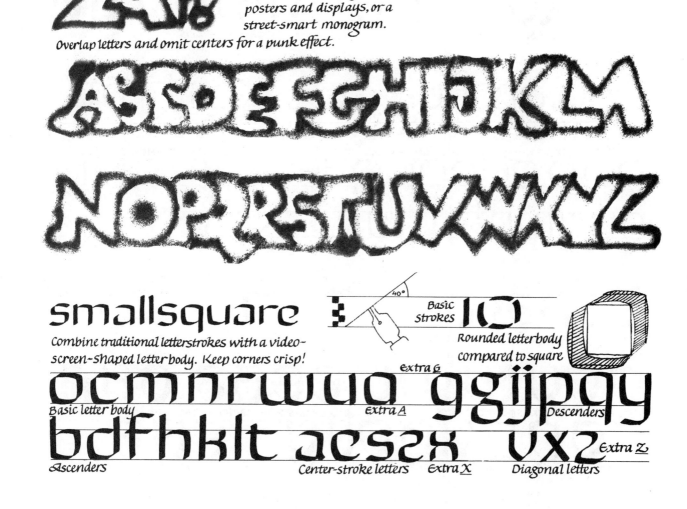

ZAP!

An informal, flexible, personal alphabet for posters and displays, or a street-smart monogram.

Overlap letters and omit centers for a punk effect.

ABCDEFGHIJKLM

NOPQRSTUVWXYZ

smallsquare

Combine traditional letterstrokes with a video-screen-shaped letter body. Keep corners crisp!

Basic Strokes 10

Rounded letterbody compared to square

extra G

ocmnrwuaa ggijpqy

Basic letter body extra A Descenders

bdfhklt acssx vxz extra Z

Ascenders Center-stroke letters extra X Diagonal letters

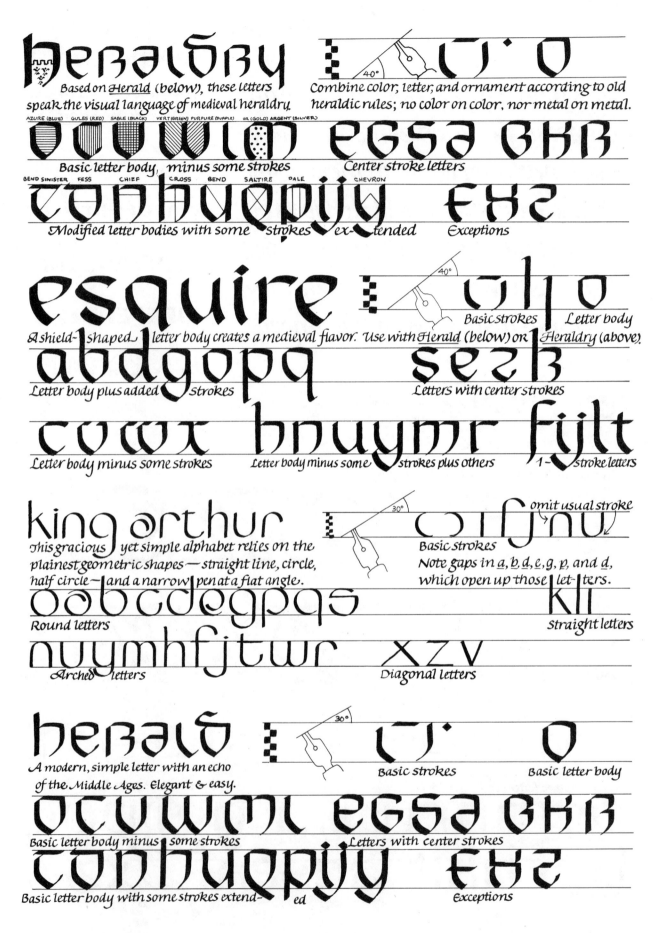

HERALDRY

Based on *Herald* (below), these letters speak the visual language of medieval heraldry.

Combine color, letter, and ornament according to old heraldic rules; no color on color, nor metal on metal.

AZURE (BLUE) GULES (RED) SABLE (BLACK) VERT (GREEN) PURPURE (PURPLE) OR (GOLD) ARGENT (SILVER)

Basic letter body, minus some strokes Center stroke letters

BEND SINISTER FESS CHIEF CROSS BEND SALTIRE PALE CHEVRON

Modified letter bodies with some strokes ex-tended Exceptions

esquire

A shield-shaped letter body creates a medieval flavor. Use with *Herald* (below) or *Heraldry* (above).

Basic strokes Letter body

Letter body plus added strokes Letters with center strokes

Letter body minus some strokes Letter body minus some strokes plus others 1-stroke letters

king arthur

This gracious yet simple alphabet relies on the plainest geometric shapes — straight line, circle, half circle — and a narrow pen at a flat angle.

Basic strokes omit usual stroke

Note gaps in *a*, *b*, *d*, *e*, *g*, *p*, and *d*, which open up those let-ters.

Round letters straight letters

Arched letters Diagonal letters

herald

A modern, simple letter with an echo of the Middle Ages. Elegant & easy.

Basic strokes Basic letter body

Basic letter body minus some strokes Letters with center strokes

Basic letter body with some strokes extend-ed Exceptions

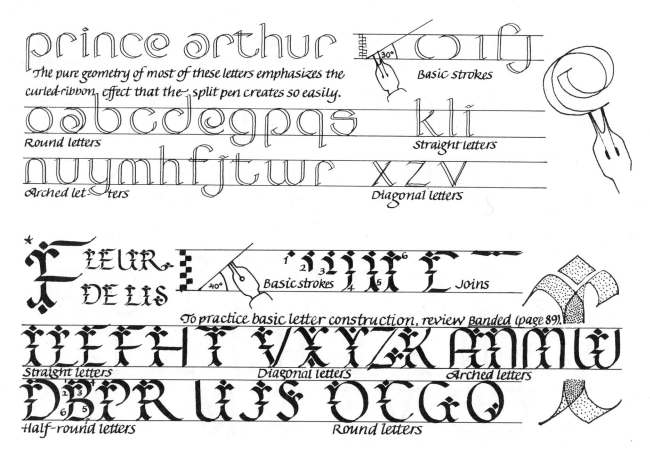

prince arthur

The pure geometry of most of these letters emphasizes the curled-ribbon effect that the split pen creates so easily.

Basic strokes

oabcdegpqs kli

Round letters *Straight letters*

nuymhfjtwr xzv

Arched letters *Diagonal letters*

FLEUR-DE LIS

Basic strokes Joins

To practice basic letter construction, review Banded (page 89).

ILEFHT VXYZKANMW

Straight letters *Diagonal letters* *Arched letters*

DBPR UJJ OCGQ

Half-round letters *Round letters*

his Week

marks not only the birthday of Ann Radcliffe (July 9) whose 'Gothic' novels focused 19-century England's fantasy on their medieval ruling class, but also Bastille Day (July 14), when the French did away with theirs. Bogus, now defunct, or meticulously correct, a coat of arms can enhance your calligraphy.

☞ MASSMAIL *These letters are made of machine-readable straight lines & deliberately awkward corners. Try it also with broad-edge pen.*

ABCDEFGHIJKLM
NOPQRSTUVWXYZ

☞ TYPEWRITER CAPS. *Each about the same width, these letters initialize Typewriter (below).*

QWERTYUIOP
ASDFGHJKL;
ZXCVBNM,.?

☞ typewriter. *Letters occupy equal space. For a "manual" effect, use uneven baseline;* type.

qwertyuiop
asdfghjkl;
zxcvbnm,.?

☞ CRYSTAL

Based on calculator displays.

Basic strokes
Watch white space.

Almost all letters
fit this framework.

OCGJULI
Basic letter outline minus some strokes

AEFHTSPdb
Basic letter outline plus some center strokes

KNRVXYZQWM
Diagonal letters

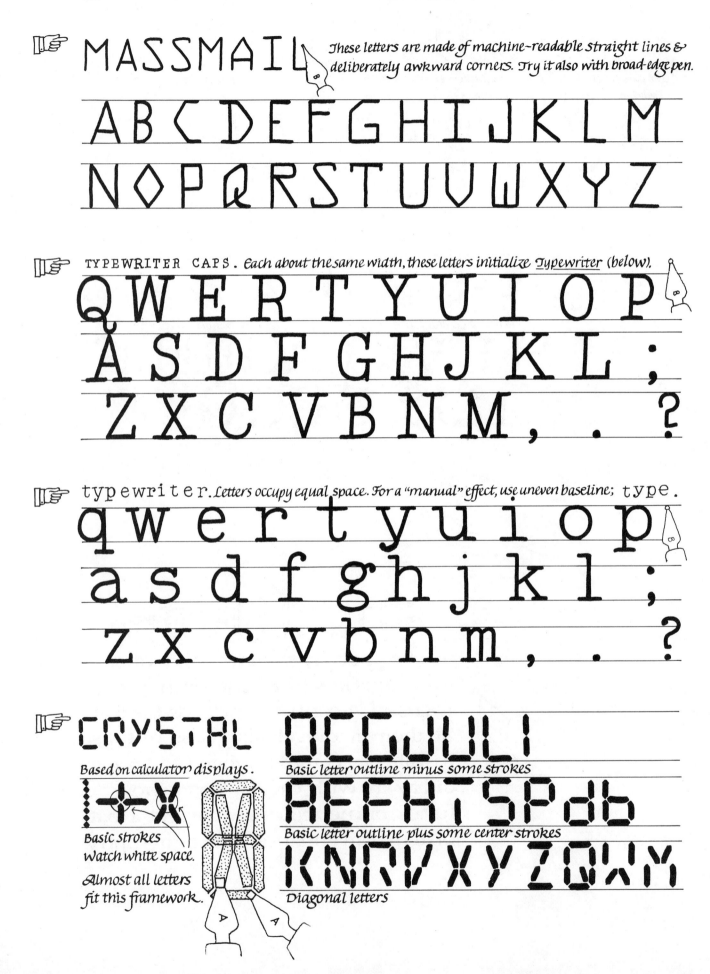

This week, use calligraphy pens to recapitulate a century of high technology—from hunt & peck to high-speed ink jet. You'll find many uses for these familiar letters and for the new calligraphic techniques they teach you.

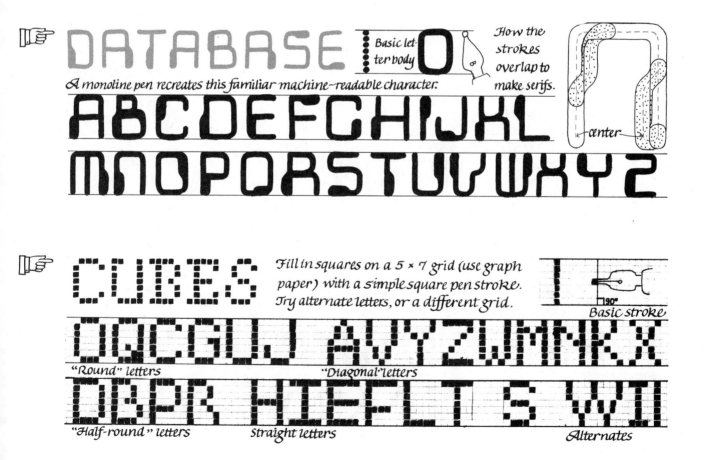

☞ **DATABASE**

Basic letter body **O**

How the strokes overlap to make serifs.

A monoline pen recreates this familiar machine-readable character.

center

ABCDEFGHIJKL
MNOPQRSTUVWXYZ

☞ **CUBES**

Fill in squares on a 5 × 7 grid (use graph paper) with a simple square pen stroke. Try alternate letters, or a different grid.

90°
Basic stroke

OQCGUJ AVYZWMNKX
"Round" letters *"Diagonal" letters*

DBPR HIEFLT S VTI
"Half-round" letters *straight letters* *Alternates*

INTERRUPTUS

The repeated small white gap carries the eye across a word while adding visual interest.

40°

Basic strokes

Keep this gap uniform.

ILEFHT NAXVYZWMK
Straight letters *Diagonal letters*

DBPR UJS OCGQ NA
Half-round letters *Curved letters* *Round letters* *Alternates*

bubbly

A split-pen version of Blister *(page 22). The two lines touch here but do not overlap.*

40°

Basic strokes Letter body Extensions

Open-top & bottom letters

Closed letters *Open-side letters* *1-stroke letters* *Extra* X *Alternate* Z

★

SKATED SPLIT SWASH

Use half of a double-pointed pen to detail the end of the swash.

40°

Basic strokes

Roll the pen onto its left point to make this stroke.

Straight narrow letters *Round letters* *Diagonal letters*

Half-round letters *Medium straight letters* *Wide diagonal letters*

SQUARIF

A square stroke finishes off many stroke ends.

30°

Basic strokes

1 pen width

How the serif joins the main stroke

½ pen width

ILEFHT DBPR UJS
Straight letters *Half-round letters*

OCGQ NAXVYZWMK
Round letters *Diagonal letters*

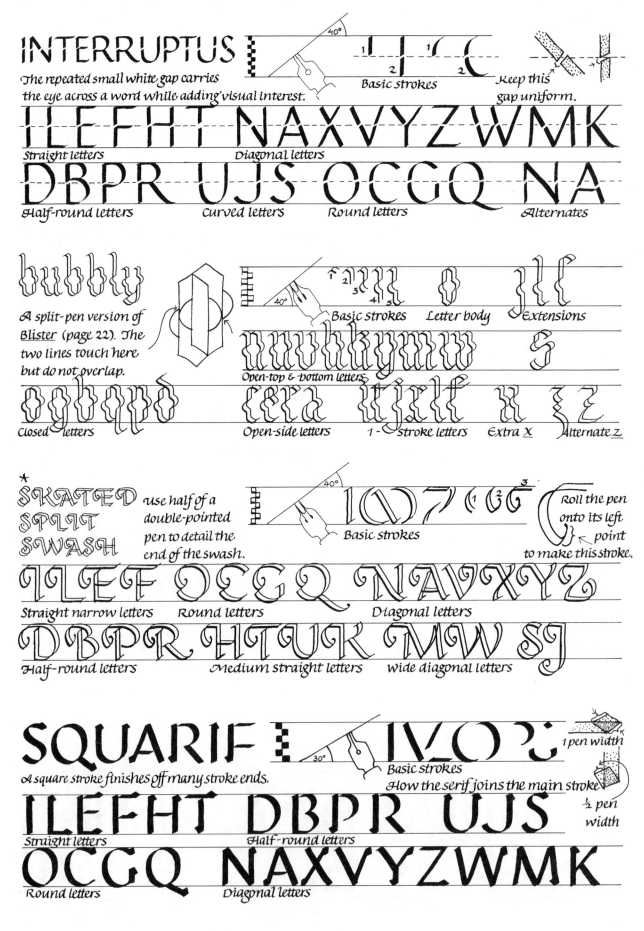

CHIP OFF THE OLD BLOCK

A modification of Basic Block (page 38) where strokes touch but don't overlap.

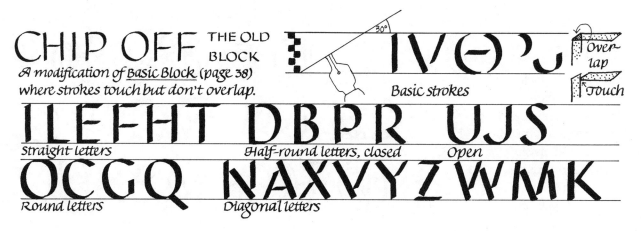

Basic strokes

Over-lap

Touch

ILEFHT DBPR UJS

Straight letters　　Half-round letters, closed　　Open

OCGQ NAXVYZWMK

Round letters　　Diagonal letters

In the United States, more babies are born on Tuesday than on any other day of the week. Celebrate the arrival of a Tuesday's child (or almost any other except perhaps a Wednesday's!) with a handlettered copy of the traditional poem. Personalize it with the baby's date of birth, name, height, weight, and a sketch, photograph, or handprint.

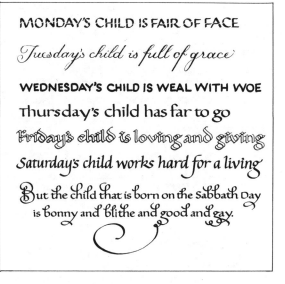

MONDAY'S CHILD IS FAIR OF FACE

Tuesday's child is full of grace

WEDNESDAY'S CHILD IS WEAL WITH WOE

Thursday's child has far to go

Friday's child is loving and giving

Saturday's child works hard for a living

But the child that is born on the Sabbath Day is bonny and blithe and good and gay.

☞ **fat mono**

A friendly-looking style. Compare with Very Light Mono (page 105).

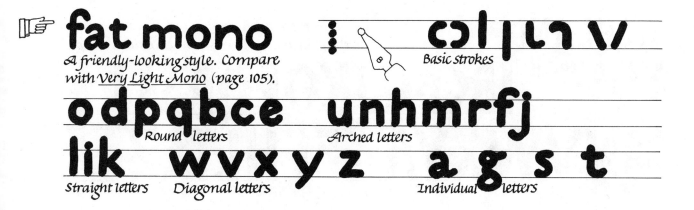

Basic strokes

odpqbce　**unhmrfj**

Round letters　　Arched letters

lik　**wvxyz**　**a g s t**

Straight letters　Diagonal letters　　Individual letters

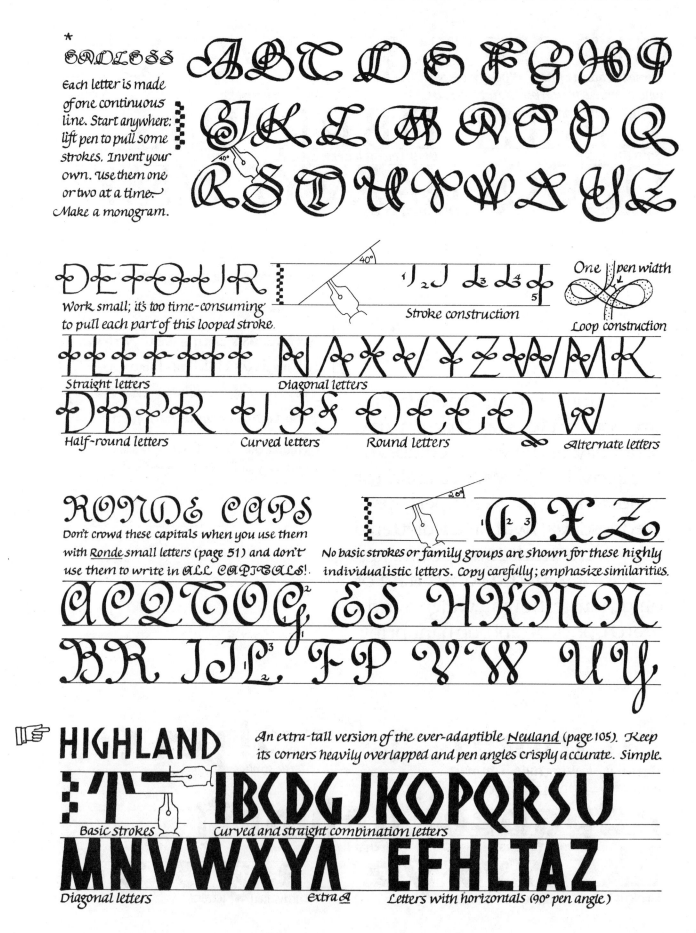

ENDLESS

Each letter is made of one continuous line. Start anywhere: lift pen to pull some strokes. Invent your own. Use them one or two at a time. Make a monogram.

ABCDEFGHIJKLMNOPQRSTUVWXYZ

DETOUR

Work small; it's too time-consuming to pull each part of this looped stroke.

Stroke construction

Loop construction
One pen width

Straight letters Diagonal letters
Half-round letters Curved letters Round letters Alternate letters

RONDE CAPS

Don't crowd these capitals when you use them with Ronde small letters (page 51) and don't use them to write in ALL CAPITALS!

No basic strokes or family groups are shown for these highly individualistic letters. Copy carefully; emphasize similarities.

HIGHLAND

An extra-tall version of the ever-adaptible Neuland (page 105). Keep its corners heavily overlapped and pen angles crisply accurate. Simple.

Basic strokes Curved and straight combination letters
IBCDGJKOPQRSU

Diagonal letters Extra A Letters with horizontals (90° pen angle)
MNVWXYA EFHLTAZ

☞ **DOUBLE DECO**

Based on _Mono Deco_ (page 38), this style doubles some strokes (generally uprights).

IVOP
Basic strokes

IL EH T · DBPRR _Extra R_ · USSS _Extra S_

Straight letters · *Half-round letters* · *Curved letters*

OCGQ · NAXVYZW MKK

Round letters · *Diagonal letters* · _Extra K_

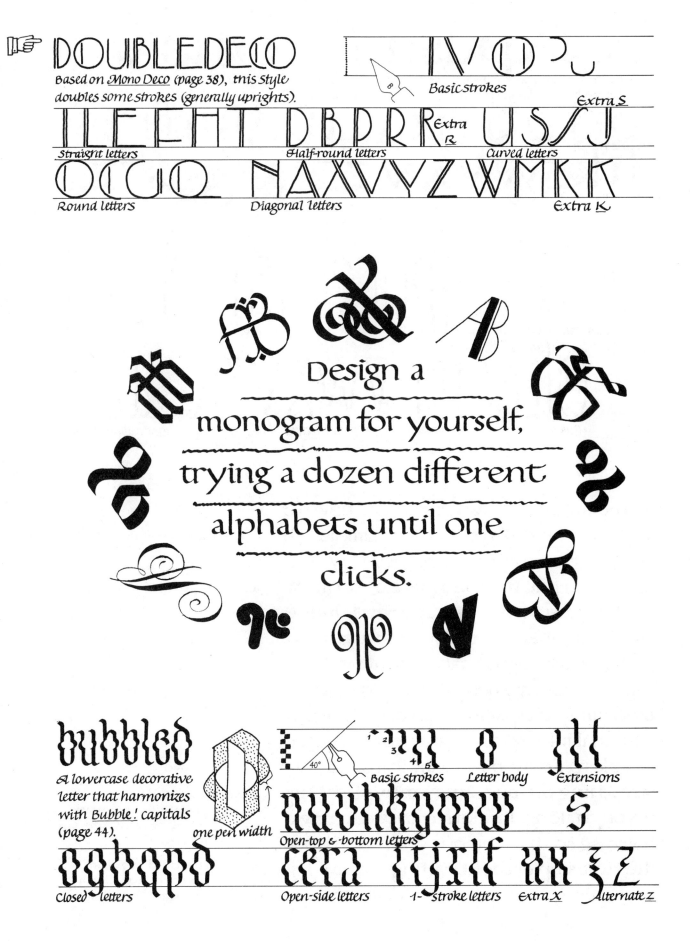

Design a
monogram for yourself,
trying a dozen different
alphabets until one
clicks.

bubbled

A lowercase decorative letter that harmonizes with _Bubble!_ capitals (page 44).

one pen width

Basic strokes · *Letter body* · *Extensions*

nuvhkymw · S

Open-top & bottom letters

ogbqpd

Closed letters

cera · itjrlf · ux · zz

Open-side letters · *1-stroke letters* · _Extra X_ · _Alternate Z_

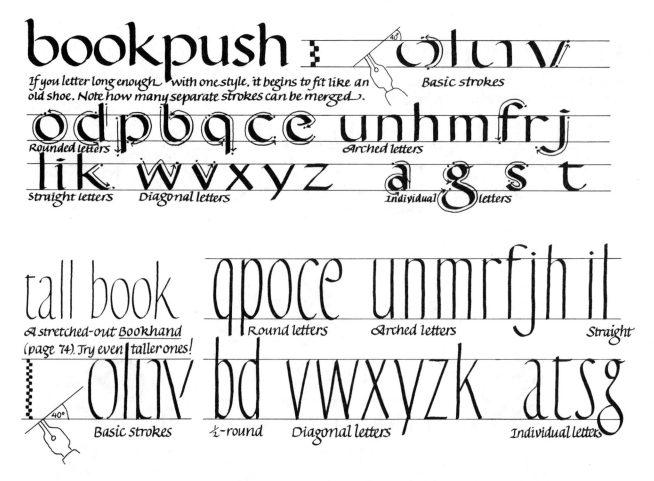

bookpush

If you letter long enough with one style, it begins to fit like an old shoe. Note how many separate strokes can be merged.

Basic strokes

Rounded letters *Arched letters*

Straight letters *Diagonal letters* *Individual letters*

tall book

A stretched-out Bookhand (page 74). Try even taller ones!

Basic strokes

Round letters *Arched letters* *Straight*

½-round *Diagonal letters* *Individual letters*

Non-calligraphers always wonder how we make the lines all come out the same length ('flush left and right'). One easy way is to letter each line first on a piece of scratch paper, measure the gap at the end, divide by the number of wordspaces, augment each wordspace by that amount, and then reletter. Next try pencilling-in the words, eyeballing the spacing and correcting it in the final inking-in. As you progess, you'll be able to 'justify' by winging it, instinctively stretching or squeezing, or hyphenating as you go along. It's akin to approaching a staircase so that you put your foot upon the first step without falling or to making your money last from one payday to the next.

WORDSPACING

justification is no problem if

Divide this gap....

justification is no problem if

....into four parts...

justification is no problem if

...and distribute them evenly.

justification is no problem if

LETTERSPACING

justification is no problem if you manipulate letterspacing when wordspacing won't suffice.

Gaps in second line are too large.

justification is no problem if you manipulate letterspacing when wordspacing won't suffice.

Spread letterspacing slightly to reduce wordspacing.

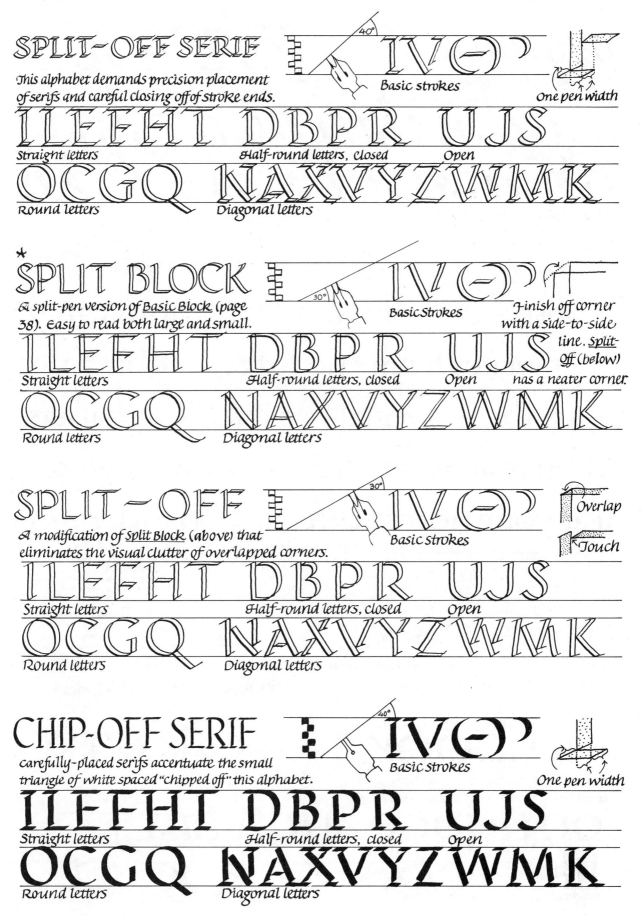

SPLIT-OFF SERIF

This alphabet demands precision placement of serifs and careful closing off of stroke ends.

Basic strokes

One pen width

ILEFHT DBPR UJS

Straight letters · Half-round letters, closed · Open

OCGQ NAXVYZWMK

Round letters · Diagonal letters

* # SPLIT BLOCK

A split-pen version of _Basic Block_ (page 38). Easy to read both large and small.

Basic Strokes

Finish off corner with a side-to-side line. Split-Off (below) has a neater corner.

ILEFHT DBPR UJS

Straight letters · Half-round letters, closed · Open

OCGQ NAXVYZWMK

Round letters · Diagonal letters

SPLIT-OFF

A modification of _Split Block_ (above) that eliminates the visual clutter of overlapped corners.

Basic strokes

Overlap

Touch

ILEFHT DBPR UJS

Straight letters · Half-round letters, closed · Open

OCGQ NAXVYZWMK

Round letters · Diagonal letters

CHIP-OFF SERIF

carefully-placed serifs accentuate the small triangle of white spaced "chipped off" this alphabet.

Basic Strokes

One pen width

ILEFHT DBPR UJS

Straight letters · Half-round letters, closed · Open

OCGQ NAXVYZWMK

Round letters · Diagonal letters

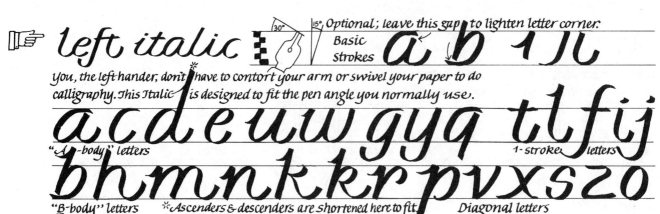

👈 *left italic* ▸ | Basic strokes | 15° Optional; leave this gap to lighten letter corner. 30° | *a b 1 n*

You, the left hander, don't have to contort your arm or swivel your paper to do calligraphy. This Italic is designed to fit the pen angle you normally use.

a c d e u w g y q t l f i j

"A-body" letters 1-stroke letters

b h m n k k r p v x s z o

"B-body" letters *Ascenders & descenders are shortened here to fit.* Diagonal letters

Today, August 13th, is Lefthanders Day. If you're one of the 15% of humanity that writes from the left, celebrate it with these special-for lefties alphabets. Then review this list of other styles. (Eat your hearts out, righthanders!)

👈 This symbol indicates an alphabet style suitable for lefthanders.

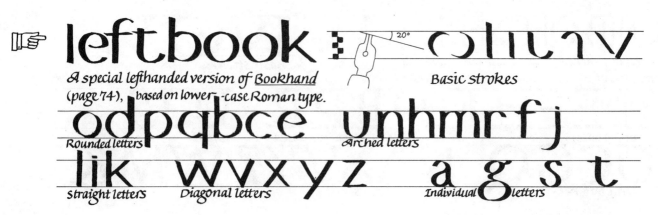

👈 **leftbook** ▸ | Basic strokes | 20° *o l l l v*

A special lefthanded version of Bookhand (page 74), based on lower-case Roman type.

o d p q b c e u n h m r f j

Rounded letters Arched letters

l i k w v x y z a g s t

straight letters Diagonal letters Individual letters

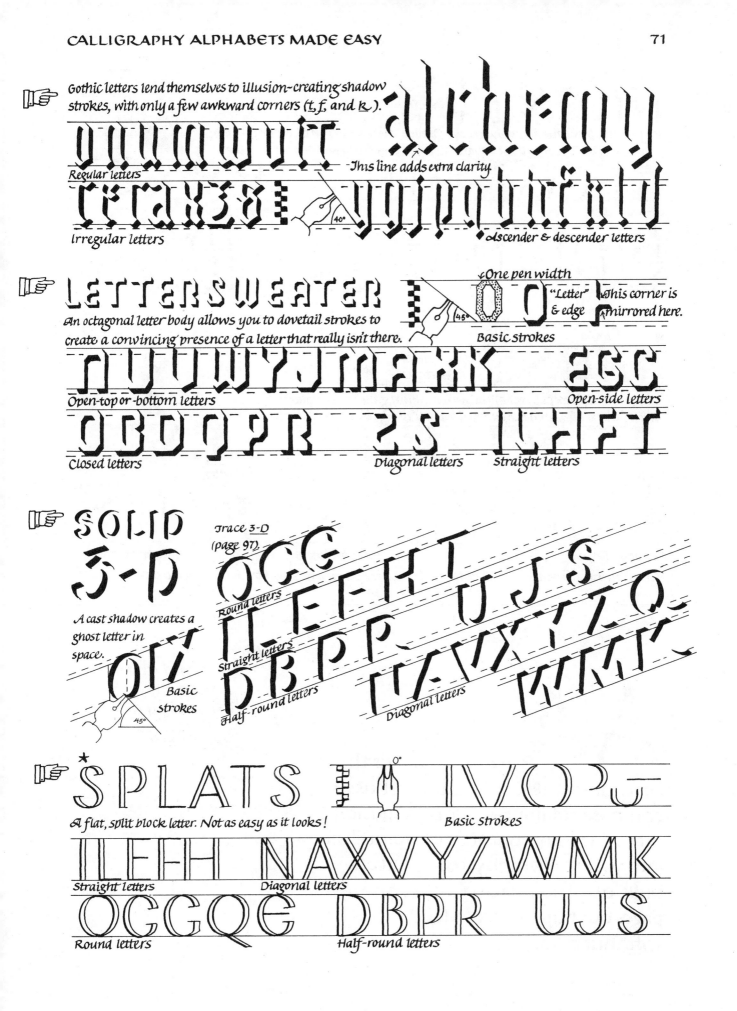

☞ Gothic letters lend themselves to illusion-creating shadow strokes, with only a few awkward corners (*t*, *f*, and *k*).

alchemy

Regular letters

—This line adds extra clarity

Irregular letters

40°

Ascender & descender letters

☞ **LETTERSWEATER**

An octagonal letter body allows you to dovetail strokes to create a convincing presence of a letter that really isn't there.

One pen width

45°

"Letter" & edge

This corner is mirrored here.

Basic strokes

Open-top or -bottom letters

Open-side letters

Closed letters

Diagonal letters

Straight letters

☞ **SOLID 3-D**

Trace 3-D (page 97)

A cast shadow creates a ghost letter in space.

Basic strokes

45°

Round letters

Straight letters

Half-round letters

Diagonal letters

☞ *★* **SPLATS**

A flat, split block letter. Not as easy as it looks!

0°

Basic strokes

Straight letters

Diagonal letters

Round letters

Half-round letters

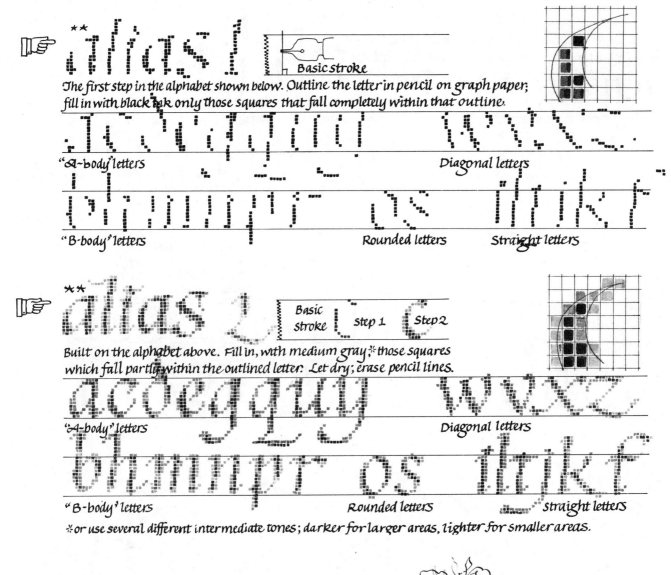

☞ ✳✳ atlas 1 | Basic stroke

The first step in the alphabet shown below. Outline the letter in pencil on graph paper; fill in with black ink only those squares that fall completely within that outline.

"A-body" letters Diagonal letters

"B-body" letters Rounded letters Straight letters

☞ ✳✳ atlas 2 | Basic Stroke | step 1 | Step 2

Built on the alphabet above. Fill in, with medium gray ✳ those squares which fall partly within the outlined letter. Let dry; erase pencil lines.

acdegguy wxz
"A-body" letters j z y Diagonal letters

bhmnpr os itikf
"B-body" letters Rounded letters straight letters

✳ or use several different intermediate tones; darker for larger areas, lighter for smaller areas.

AAA

ugust 22 marks the birthday, in 1862, of Claude Debussy, composer of impressionistic music. Introduce soft contours of pointillism into your calligraphy, using letters built up of soft dabs of color, or pages built up of soft-edged, soft-hued letters.

Now and then, shed by a blossoming tree,

a petal would come down, down, down,
and with the odd feeling of seeing
something neither worshipper nor casual spectator
ought to see, one would manage
to glimpse its reflection
which swiftly — more swiftly than the petal fell—
rose to meet it;
and for a fraction of a second,
one feared that the trick would not work,
that the blessed oil would not catch fire,
that the reflection might miss
and the petal float away alone,
but every time
the delicate union did take place,
with the magic precision
of a poet's word meeting halfway his, or
a reader's recollections.

SPEAK, MEMORY
Vladimir Nabokov

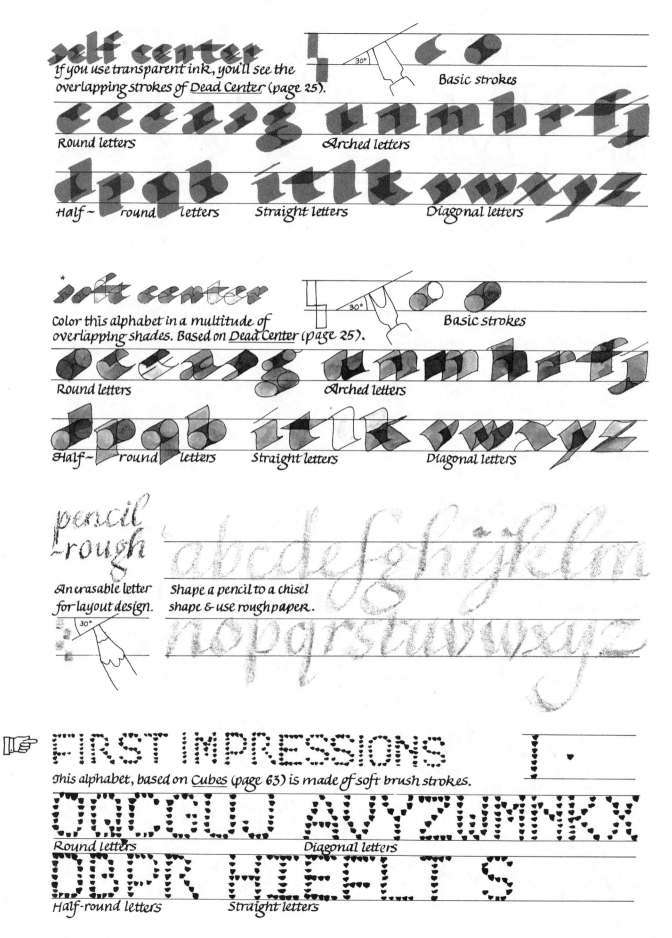

self center

If you use transparent ink, you'll see the overlapping strokes of <u>Dead Center</u> (page 25).

30°

Basic strokes

Round letters

Arched letters

Half~round letters Straight letters Diagonal letters

soft center

Color this alphabet in a multitude of overlapping shades. Based on <u>Dead Center</u> (page 25).

30°

Basic strokes

Round letters

Arched letters

Half~round letters Straight letters Diagonal letters

pencil rough

An erasable letter for layout design.

Shape a pencil to a chisel shape & use rough paper.

30°

abcdefghijklm
nopqrstuvwxyz

☞ **FIRST IMPRESSIONS**

This alphabet, based on <u>Cubes</u> (page 63) is made of soft brush strokes.

OQCGUJ AVYZWMNKX

Round letters Diagonal letters

DBPR HIEFLT S

Half-round letters Straight letters

bookhand

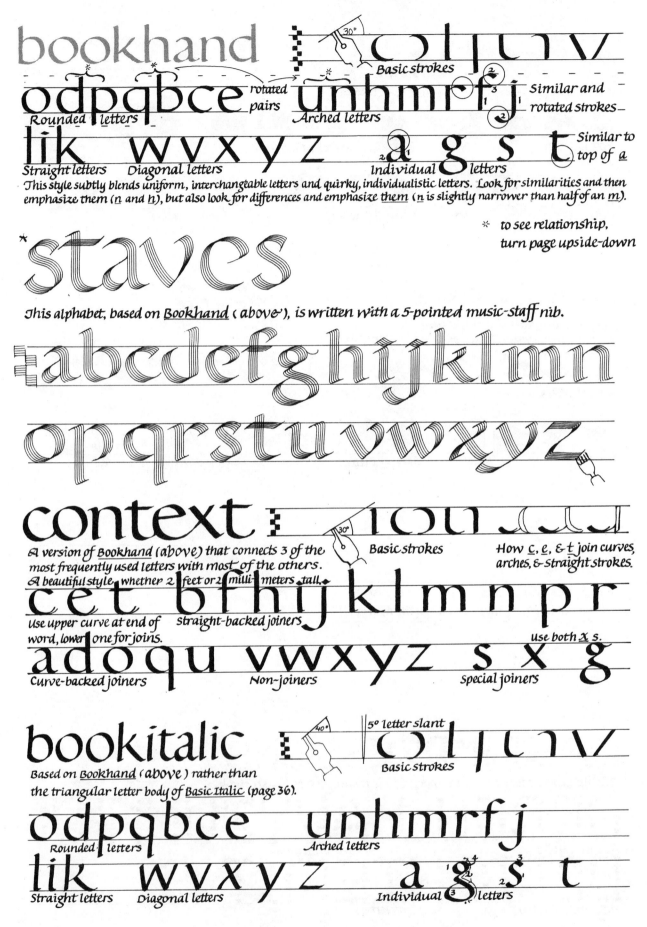

30°

Basic strokes

odpqbce *rotated pairs* unhmrfj Similar and rotated strokes

Rounded letters Arched letters

lik wvxyz agst Similar to top of a

Straight letters Diagonal letters Individual letters

This style subtly blends uniform, interchangeable letters and quirky, individualistic letters. Look for similarities and then emphasize them (n and h), but also look for differences and emphasize them (n is slightly narrower than half of an m).

* to see relationship, turn page upside-down

staves

This alphabet, based on Bookhand (above), is written with a 5-pointed music-staff nib.

abcdefghijklmn

opqrstuvwxyz

context

30°

Basic strokes

How c, e, & t join curves, arches, & straight strokes.

A version of Bookhand (above) that connects 3 of the most frequently used letters with most of the others. A beautiful style, whether 2 feet or 2 milli-meters tall.

cet bfhijklmnpr

Use upper curve at end of word, lower one for joins. straight-backed joiners

Use both x s.

adoqu vwxyz sxg

Curve-backed joiners Non-joiners special joiners

bookitalic

40° 5° letter slant

Basic strokes

Based on Bookhand (above) rather than the triangular letter body of Basic Italic (page 36).

odpqbce unhmrfj

Rounded letters Arched letters

lik wvxyz agst

Straight letters Diagonal letters Individual letters

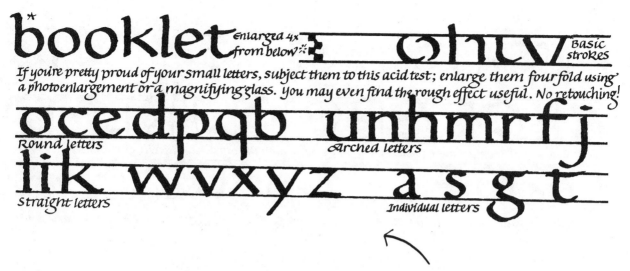

booklet *enlarged 4x from below** ꝺ ohtv *Basic strokes*

If you're pretty proud of your small letters, subject them to this acid test; enlarge them fourfold using a photoenlargement or a magnifying glass. You may even find the rough effect useful. No retouching!

ocedpqb unhmrfj
Round letters *Arched letters*

lik wvxyz a s g t
Straight letters *Individual letters*

If I had to choose just one alphabet style to letter for the rest of my life, this would be it: the simplest Bookhand, medium weight, with hairline serifs, short descenders, and generous word- & linespacing.

booklet ꝺ ohtv
ocedpqb unhmrfj
lik wvxyz a s g t

**Original size of alphabet enlarged four times above.*

Final size of letters reduced ¼ from alphabet below.

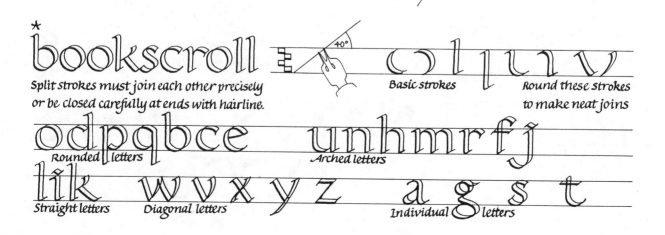

bookscroll ꝺ ohtuv *Basic strokes* *Round these strokes to make neat joins*

Split strokes must join each other precisely or be closed carefully at ends with hairline.

odpqbce unhmrfj
Rounded letters *Arched letters*

lik wvxyz a g s t
Straight letters *Diagonal letters* *Individual letters*

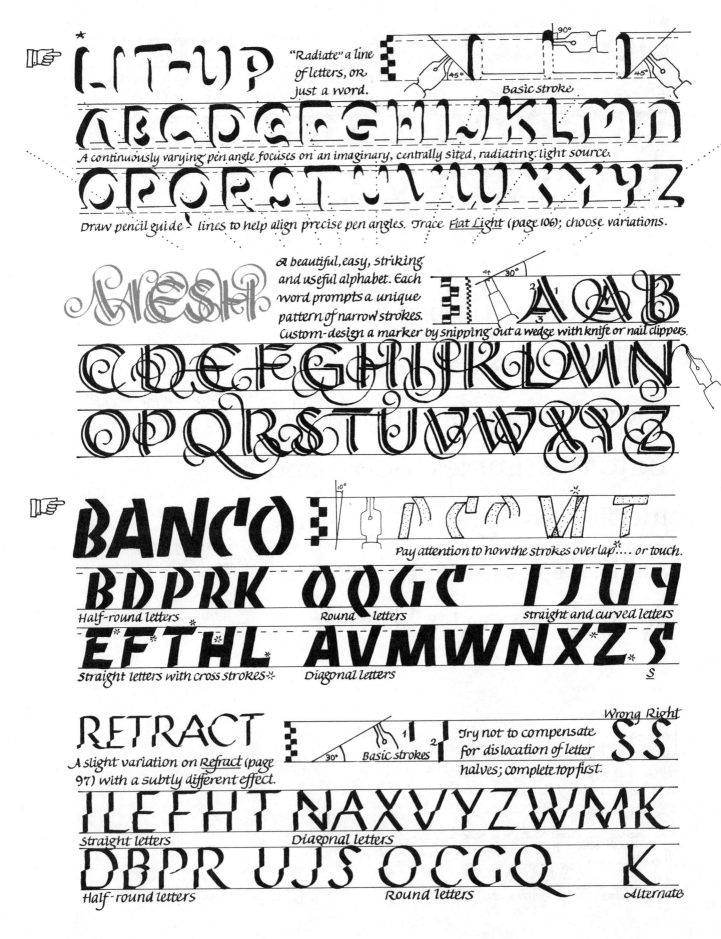

LIT-UP

"Radiate" a line of letters, or just a word.

Basic stroke

ABCDEFGHIJKLMN

A continuously varying pen angle focuses on an imaginary, centrally sited, radiating light source.

OPQRSTUVWXYZ

Draw pencil guide-lines to help align precise pen angles. Trace Flat Light (page 106); choose variations.

MESH

A beautiful, easy, striking and useful alphabet. Each word prompts a unique pattern of narrow strokes. Custom-design a marker by snipping out a wedge with knife or nail clippers.

A A B

CDEFGHIJKLMN

OPQRSTUVWXYZ

BANCO

Pay attention to how the strokes overlap.... or touch.

BDPRK OQGC IJUY

Half-round letters Round letters straight and curved letters

EFTHL AVMWNXZ S

Straight letters with cross strokes Diagonal letters S

RETRACT

A slight variation on Refract (page 97) with a subtly different effect.

Basic strokes

Try not to compensate for dislocation of letter halves; complete top first.

Wrong Right
S S

ILEFHT NAXVYZWMK

Straight letters Diagonal letters

DBPR UJS OCGQ K

Half-round letters Round letters Alternate

Banners

A split-pen version of Herald (page 60). Close the stroke ends and fill with bright medieval color.

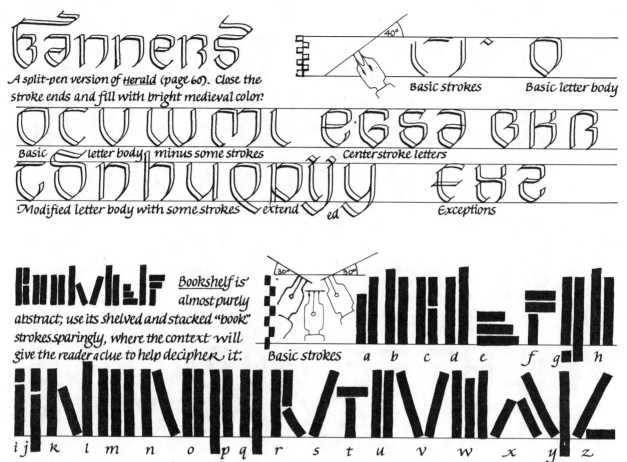

Basic strokes Basic letter body

Basic — letter body — minus some strokes Center stroke letters

Modified letter body with some strokes extended Exceptions

Bookshelf

Bookshelf is almost purely abstract; use its shelved and stacked "book" strokes sparingly, where the context will give the reader a clue to help decipher it:

Basic strokes a b c d e f g h

i j k l m n o p q r s t u v w x y z

Labor Day starts the work year for many businesses. If you are self-employed, use this lull to letter yourself a business card, or bring your old one up to date with a rendering that reflects your level of calligraphic expertise. Don't put in too much information or too many different visual messages.

LIGHTYEARS

Contemporary Italian Lighting
Newbury Street and the Chestnut Hill Mall
Boston, Massachusetts 617 · 411 · 0121

THE
EXERCISE
SPOT Nautilus, Aerobics, Pool
424-2424

21212
401 2nd Avenue, Clarence, Missouri

FLOWERS
The Ritz Hotel · Fairhaven
706 · ORCHIDS

Aquarium
supplies & fish RIPPLES

Median Mall, Vanderbilt Heights, California ~ 92044

Otis Doorland

Geneologist
Walkley House, Mooreton, South Dakota 60312
601-445-6606

CAROLYN REES GEIGER 417-277-2601

A FRIENDLY BOOKSTORE

At the corner of Locust and Wakonda, one flight up
Miltonville, Louisiana 20111

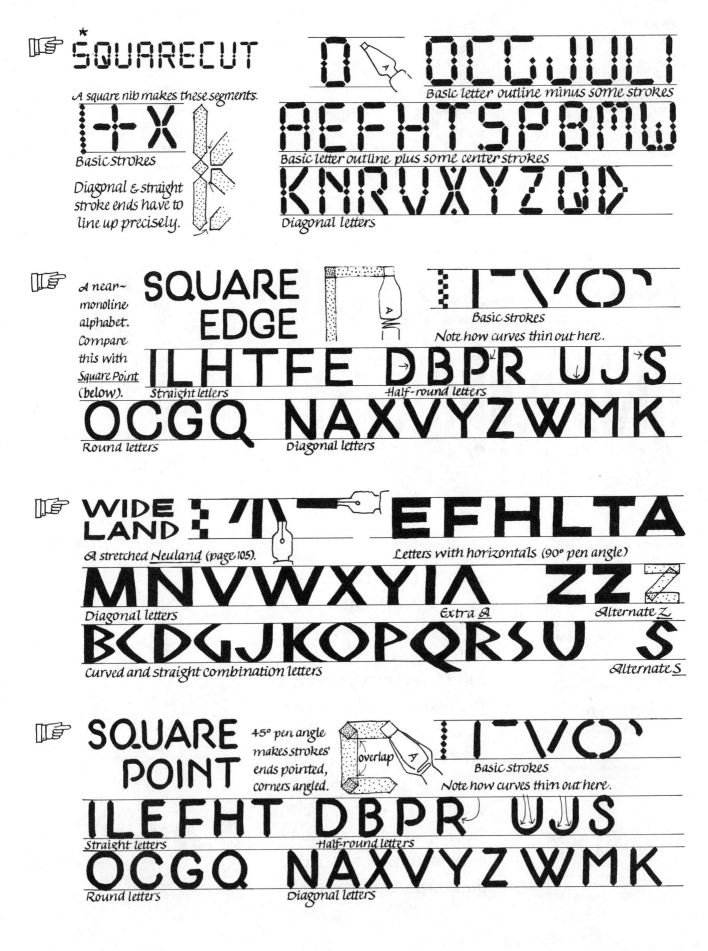

☞ *SQUARECUT

A square nib makes these segments.

Basic strokes

Diagonal & straight stroke ends have to line up precisely.

Basic letter outline minus some strokes

OCGJULI

Basic letter outline plus some center strokes

AEFHTSPBMW

Diagonal letters

KNRVXYZQD

☞ A near-monoline alphabet. Compare this with Square Point (below).

SQUARE EDGE

Basic strokes

Note how curves thin out here.

Straight letters ILHTFE Half-round letters DBPR UJS

Round letters OCGQ Diagonal letters NAXVYZWMK

☞ WIDE LAND

A stretched Neuland (page 105).

Letters with horizontals (90° pen angle)

EFHLTA

Diagonal letters MNVWXYIA Extra A ZZZ Alternate Z

Curved and straight combination letters BCDGJKOPQRSU S Alternate S

☞ SQUARE POINT

45° pen angle makes strokes' ends pointed, corners angled. overlap

Basic strokes

Note how curves thin out here.

Straight letters ILEFHT Half-round letters DBPR UJS

Round letters OCGQ Diagonal letters NAXVYZWMK

The first Friday the 13th of every year is Blame Someone Else Day; the rest of the year your calligraphic flubs are your own fault. Since September is Be Kind to Editors and Writers Month, learning to critique and proofread your own work will help make everybody's job easier. First, judge your work graphically; turn it upside down, step back, and squint at it; are the horizontals horizontal and the verticals vertical? Is the text of an even texture? Do the right things engage the eye? Next, go back to the original that you worked from and read it aloud to an assistant who checks the copy that you lettered. Be sure you read everything; say 'capital b,' 'semicolon,' 'period,' & spell out any potential problem words. With patience & luck you'll catch most of the omissions, repetitions, & typos, but don't stop yet. Have a *third person* check off, one by one, the corrections you did so no new errors creep in there! Even then one may still slip by...

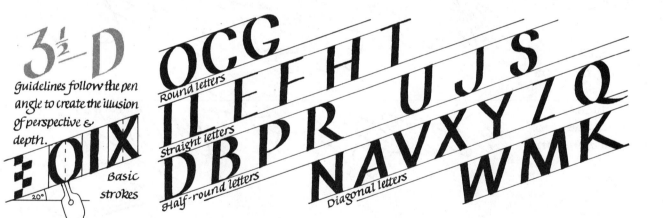

Guidelines follow the pen angle to create the illusion of perspective & depth.

Basic strokes

20°

Round letters

Straight letters

Half-round letters

Diagonal letters

This alphabet uses fewer cuts than <u>Cut</u> (page 103) to create letters out of spaces.

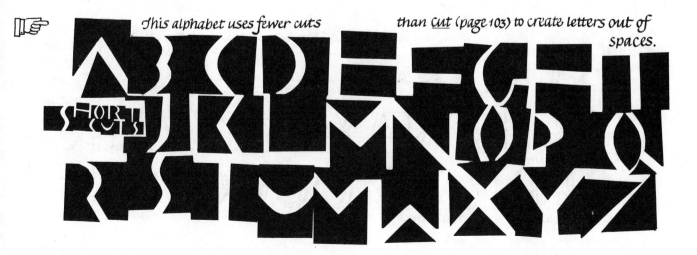

SHORT CUTS

Sometimes less work has more results. Concentrate your effort & time on the most important two or three words in any poster; emphasize them; then employ your easiest, simplest lettering style for the details.

GALA GOLDEN ANNIVERSARY CELEBRATION AND BALL·MAY 21, SIX O'CLOCK OPERA HOUSE·

GALA

GOLDEN ANNIVERSARY
CELEBRATION AND BALL

May 21, six o'clock, Opera House~

echo

abcdefghijklm
nopqrstuvwxyz

Join 2 contrasting markers with masking tape, and write with big, free arm motions.

*

CRUX
Simple but visually complex.

40°

Basic stroke construction

Center→

Angles & strokes must be precise.

ILEFHT NAXVYZWMK
Narrow straight letters Diagonal letters

DBPR UJS OCGQ MX
Half-round letters Curved letters Round letters Alternates

SLIT PERSONALITY

A useful gapped-stroke style that can mix with un-gapped letters. Time-consuming but not difficult.

30°
1
2
3
Basic strokes

Move pen side to side to make a hairline.

One pen width.
½ pen width.

ILEFHT NAXVYZWMK
Straight letters Diagonal letters

DBPR UJS OCGQ QZ
Half-round letters Curved letters Round letters Alter-nates

★★ lightning

A zigzag outline jazzes up this alphabet, built on the framework of the Basic Gothic letter (page 20).

40°
1
2
3
4
5
Basic strokes Letter body Extensions

Open-top & bottom letters

Closed letters

Open-side letters 1-stroke letters Extra X Alternate Z

★ BRACKETED

Each doubled stroke traps a small square in its symmetrical white space.

30°
1
2
3
4
5
Basic stroke construction

center
Keep white space equal.

ILEFHT NAXVYZWMK
Straight letters Diagonal letters

DBPR UJS OCGQ MX
Half-round letters Curved letters Round letters Alternates

BLOT

ABCDEFGHIJKLM
NOPQRSTUVWXYZ

Skip the pen altogether; try writing with the India ink bottle dropper stopper. Work flat to preclude drips.

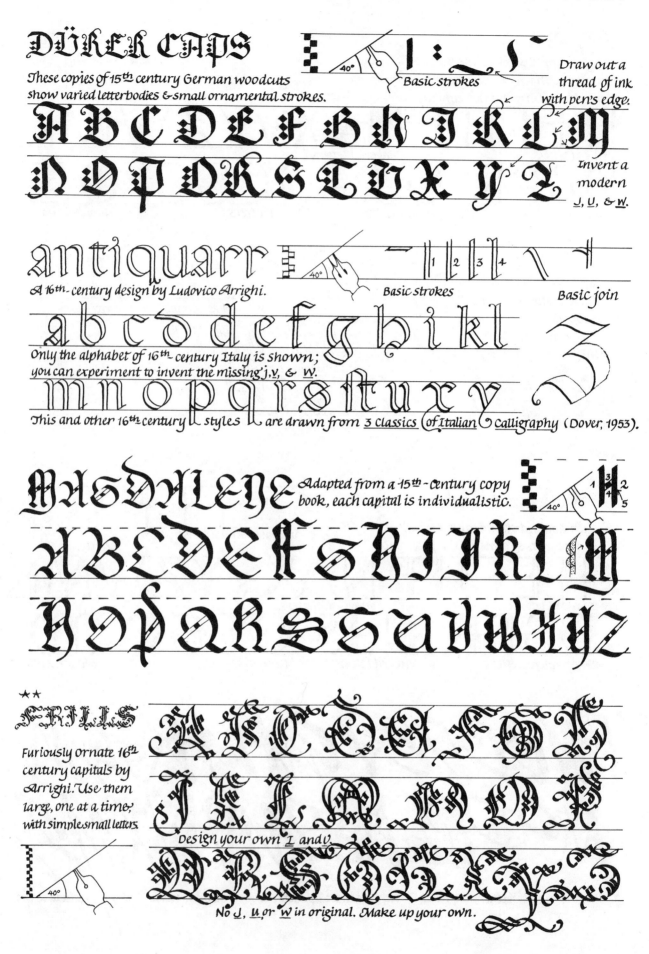

DÜRER CAPS

These copies of 15ᵗʰ century German woodcuts
show varied letterbodies & small ornamental strokes.

40°　Basic strokes

Draw out a
thread of ink
with pen's edge.

A B C D E F G H I K L M

N O P Q R S T V X Y Z

Invent a
modern
J, U, & W.

antiquarr

A 16ᵗʰ-century design by Ludovico Arrighi.

40°　Basic strokes　　　Basic join

a b c d d e f g h i k l

Only the alphabet of 16ᵗʰ-century Italy is shown;
you can experiment to invent the missing j, v, & w.

m n o p q r s t u x y

This and other 16ᵗʰ century styles are drawn from 3 classics of Italian Calligraphy (Dover, 1953).

MAGDALENE

Adapted from a 15ᵗʰ-century copy
book, each capital is individualistic.

40°

A B C D E F G H I J K L M

N O P Q R S T U V W X Y Z

✶✶ FRILLS

Furiously ornate 16ᵗʰ
century capitals by
Arrighi. Use them
large, one at a time,
with simple small letters.

40°

Design your own I and v.

No J, U, or W in original. Make up your own.

This week includes Ancestor Appreciation Day. In memory, copy these historical alphabets using your eye, not your brain; copy what is actually there, not what you think you know is there; resist making all those minor visual adjustments that dilute an alphabet's flavor. To check this tendency, turn your paper & your original upside-down; this keeps your brain from interfering with your eye.

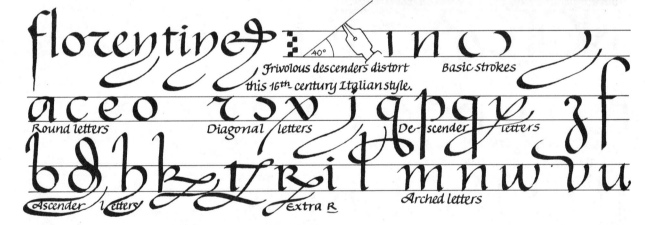

florentine

Frivolous descenders distort this 16th century Italian style.

Basic strokes

Round letters Diagonal letters De- scender letters

Ascender letters Extra R Arched letters

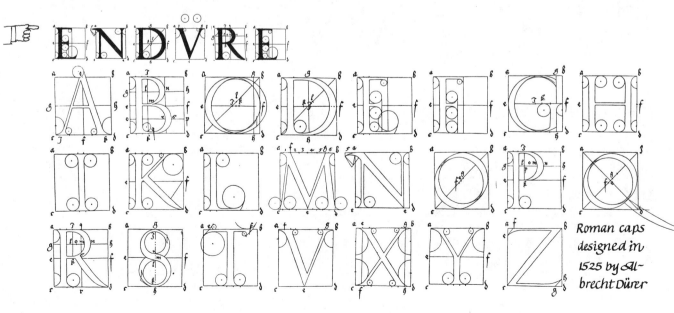

ENDVRE

Roman caps designed in 1525 by Albrecht Dürer

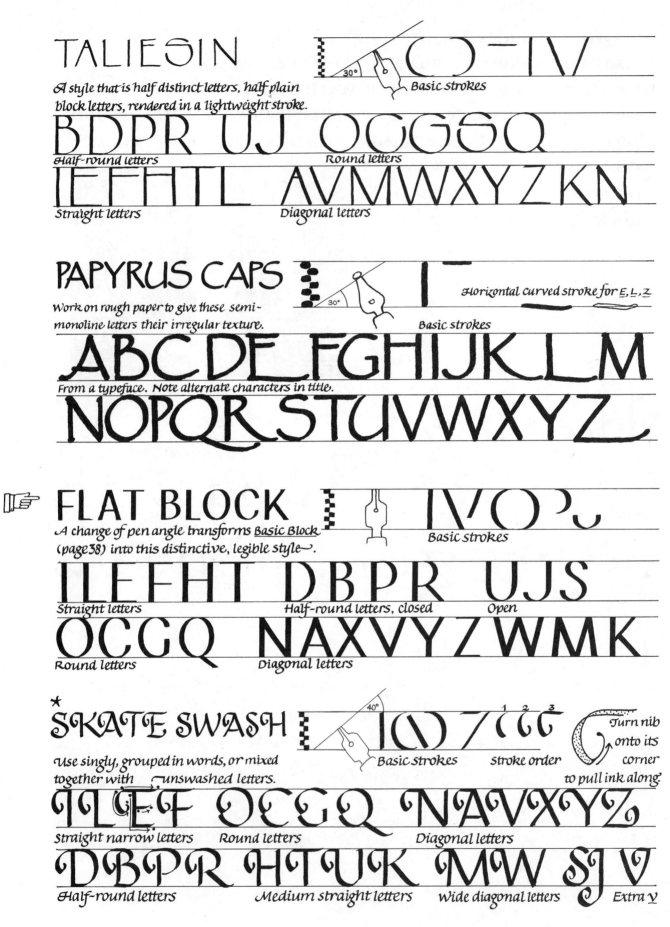

TALIESIN

A style that is half distinct letters, half plain block letters, rendered in a lightweight stroke.

30°　Basic strokes

BDPR UJ OOCGSQ

Half-round letters　　　　　Round letters

IEFHTL AVMWXYZKN

Straight letters　　　　Diagonal letters

PAPYRUS CAPS

Work on rough paper to give these semi-monoline letters their irregular texture.

30°　Basic strokes

Horizontal curved stroke for E, L, Z

ABCDE FGHIJKL M

From a typeface. Note alternate characters in title.

NOPQR STUVWXYZ

☞ # FLAT BLOCK

A change of pen angle transforms Basic Block (page 38) into this distinctive, legible style—.

Basic strokes

ILEFHT DBPR UJS

Straight letters　　　Half-round letters, closed　　Open

OCGQ NAXVYZWMK

Round letters　　　Diagonal letters

★ # SKATE SWASH

Use singly, grouped in words, or mixed together with ⌐unswashed letters.

40°　Basic strokes　　Stroke order

1 2 3

Turn nib onto its corner to pull ink along.

ILEF OCGQ NAVXYZ

Straight narrow letters　　Round letters　　Diagonal letters

DBPR HTUK MW SJV

Half-round letters　　Medium straight letters　　Wide diagonal letters　　Extra V

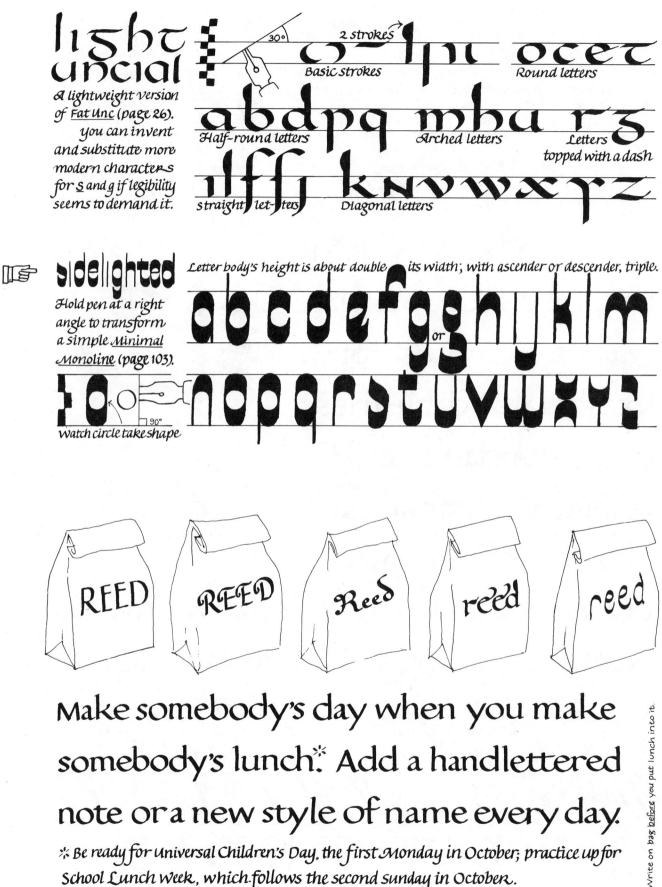

light uncial

A lightweight version of Fat Unc (page 26).
You can invent and substitute more modern characters for s and g if legibility seems to demand it.

30° 2 strokes o-lii ocet
Basic strokes Round letters

a b d p q m h u r ʒ
Half-round letters Arched letters Letters topped with a dash

il f ʃ i k n v w x ʏ z
straight let-ters Diagonal letters

sidelighted

Hold pen at a right angle to transform a simple Minimal Monoline (page 103).

Letter body's height is about double its width; with ascender or descender, triple.

a b c d e f g g h y k l m
or
n o p q r s t u v w x y

90°
watch circle take shape

REED REED Reed reed reed

Make somebody's day when you make somebody's lunch.* Add a handlettered note or a new style of name every day.

* Be ready for Universal Children's Day, the first Monday in October; practice up for School Lunch Week, which follows the second Sunday in October.

Write on bag before you put lunch into it.

☞ *copperplate*

30° — Change pressure *abruptly...*
∅ ∅ *nut* *...or slowly.*
Stroke is straight most of its
length and then curves in
a semicircle.

Based on 18th & 19th century handwriting. Exaggerate its slant and the ascender height and the difference between thick and thin strokes.

oace rsx zfgy qpf

Round letters Individual letters Descenders: ...round... and straight

blhk tdi mnuvw rs

Ascenders: round...and straight Arched letters Alternates

Victorian handwriting that we call 'Copperplate' was the accepted form for social and business correspondance, and for commercial transactions. Try several variations during Bookkeepers & Letterwriting Weeks, the second week in October.

Position of the Hand in Flourishing.

In executing broad sweeps with the pen, and assuming a position that will give greatest command of the hand in flourishing, the position of the pen in the hand should be reversed; the end of the penholder pointing *from* the left shoulder, the pen pointing towards the body, the holder being held between the thumb and two first fingers, as shown above.

☞ *COPPER CAPS*

30° *ABC*

An ornate lightweight capital. Use with Copperplate (above).

DEF GHIJKL MNO

PQRSTUVWXYZ

☞ *copperwire*

A pressure-sensitive letter with a minimum of overlapped lines.

Symmetry Letter construction features small and large corner curves.

Round letters Individual letters Descenders: round & straight

Ascenders: round and straight Arched letters Alternate letters

☞ *copperstraight*

An upright version of Copperplate (page 86) that is easier for a right-hander.

Symmetrical letter body

Round letters Individual letters Descenders: ... round ... and ... straight

Ascenders: round ... and straight Arched letters Alternates

Copperleaning

A version of Copperplate (page 86) that reverses the letter angle and shifts the stroke weight downward to fit the right-handed calligrapher's pen.

Round letters Individual letters Descenders: round ... straight ... & curled

Ascenders: round ... and straight Arched letters Alternates

☞

Basic strokes These letters have lots of decorative swashes. There are very few thick strokes, and what few there are aren't very thick.

Bury the
hatchet
but mark
the spot.

Columbus Day celebrates the discovery of the Americas, North & South. Pre-Columbian American Indians, while they did not practice alphabetic writing as we know it, had highly-developed traditions of graphic forms to supplement their oral culture, and decorative arts that can lend a strong flavor to the alphabets of today. Use them to create an atmosphere.

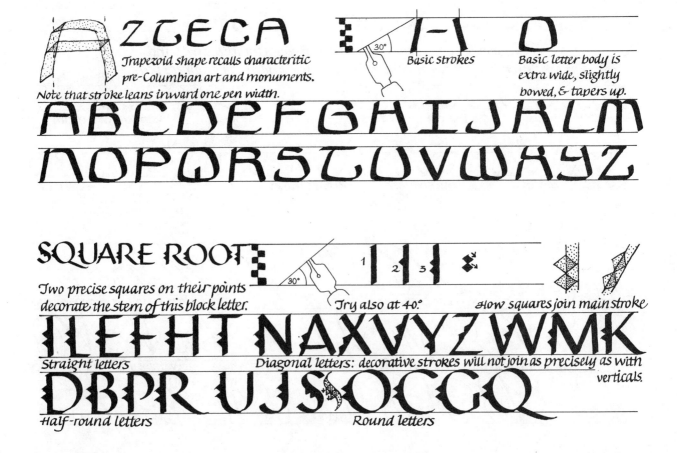

AZTECA

Trapezoid shape recalls characteritic pre-Columbian art and monuments. Note that stroke leans inward one pen width.

30° Basic strokes Basic letter body is extra wide, slightly bowed, & tapers up.

ABCDEFGHIJKLM
NOPQRSTUVWAYZ

SQUARE ROOT

Two precise squares on their points decorate the stem of this block letter.

30° 1 2 3 Try also at 40° How squares join main stroke

ILEFHT NAXVYZWMK

Straight letters Diagonal letters: decorative strokes will not join as precisely as with verticals.

DBPR UJSOCGQ

Half-round letters Round letters

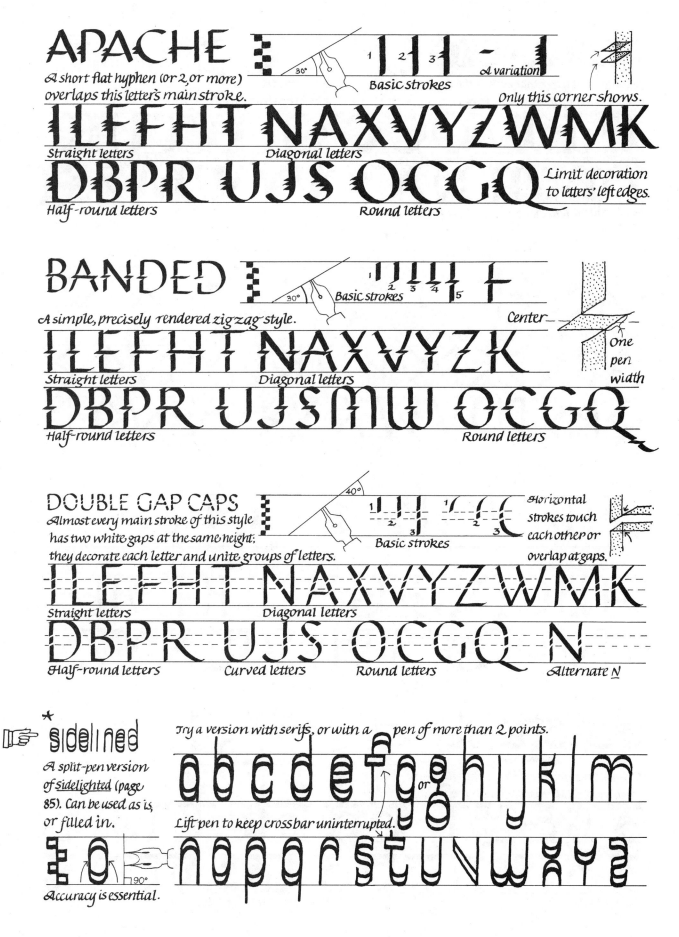

APACHE

A short flat hyphen (or 2, or more) overlaps this letter's main stroke.

Basic strokes — 1 2 3 — A variation

Only this corner shows.

ILEFHT NAXVYZWMK

Straight letters — Diagonal letters

DBPR UJS OCGQ

Half-round letters — Round letters

Limit decoration to letters' left edges.

BANDED

A simple, precisely rendered zigzag style.

Basic strokes — 1 2 3 4 5

Center — One pen width

ILEFHT NAXVYZK

Straight letters — Diagonal letters

DBPR UJSMW OCGQ

Half-round letters — Round letters

DOUBLE GAP CAPS

Almost every main stroke of this style has two white gaps at the same height; they decorate each letter and unite groups of letters.

Basic strokes

Horizontal strokes touch each other or overlap at gaps.

ILEFHT NAXVYZWMK

Straight letters — Diagonal letters

DBPR UJS OCGQ N

Half-round letters — Curved letters — Round letters — Alternate N

☞ *sidelined

A split-pen version of sidelighted (page 85). Can be used as is, or filled in.

Accuracy is essential.

Try a version with serifs, or with a pen of more than 2 points.

a b c d e f g or g h i j k l m

Lift pen to keep crossbar uninterrupted.

n o p q r s t u v w x y z

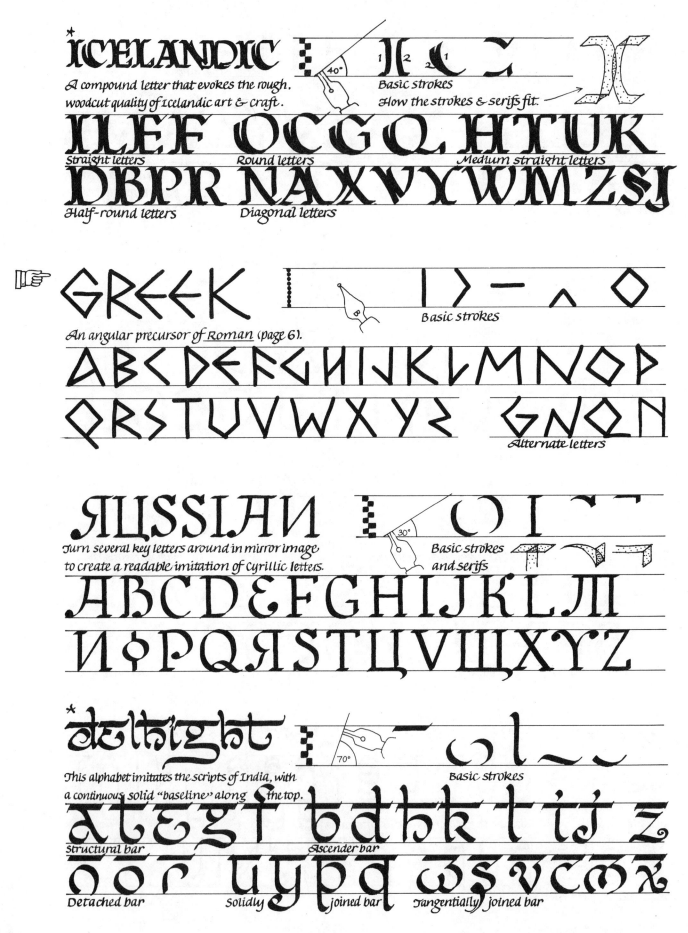

*ICELANDIC

A compound letter that evokes the rough, woodcut quality of Icelandic art & craft.

40°

Basic strokes

How the strokes & serifs fit.

ILEF OCGQ HTUK

Straight letters Round letters Medium straight letters

DBPR NAXVYWMZSJ

Half-round letters Diagonal letters

☞ GREEK

An angular precursor of Roman (page 6).

Basic strokes

ABCDEFGHIJKLMNOP

QRSTUVWXYZ GNΘN

Alternate letters

RUSSIAN

Turn several key letters around in mirror image to create a readable imitation of Cyrillic letters.

30°

Basic strokes and serifs

ABCDEFGHIJKLM

NOPQRSTUVWXYZ

*delhight

This alphabet imitates the scripts of India, with a continuous solid "baseline" along the top.

70°

Basic strokes

atεsf bdhk tij z

Structural bar Ascender bar

oor uypq wsvcmx

Detached bar Solidly joined bar Tangentially joined bar

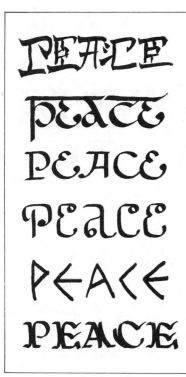

United Nations Day falls on October 24, the anniversary of its founding in 1946. Commemorate this with 'Peace' written in half a dozen languages, or use West-ernized versions of non-Western scripts to lend international flavor to menues, announcements, logos, and headlines.

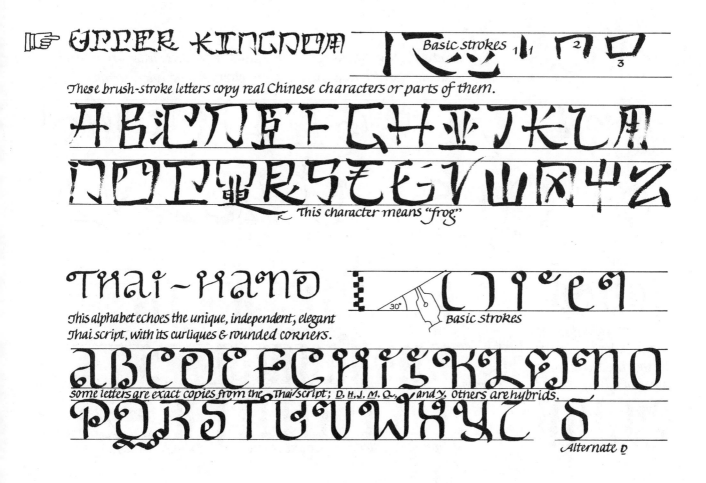

UPPER KINGDOM Basic strokes

These brush-stroke letters copy real Chinese characters or parts of them.

A B C D E F G H I J K L M
N O P Q R S T U V W X Y Z

← This character means "frog"

THAI~HAND Basic strokes

This alphabet echoes the unique, independent, elegant Thai script, with its curliques & rounded corners.

A B C D E F G H I J K L M N O

Some letters are exact copies from the Thai script; D, H, J, M, O, and Y. Others are hybrids.

P Q R S T U V W X Y Z ð

Alternate D

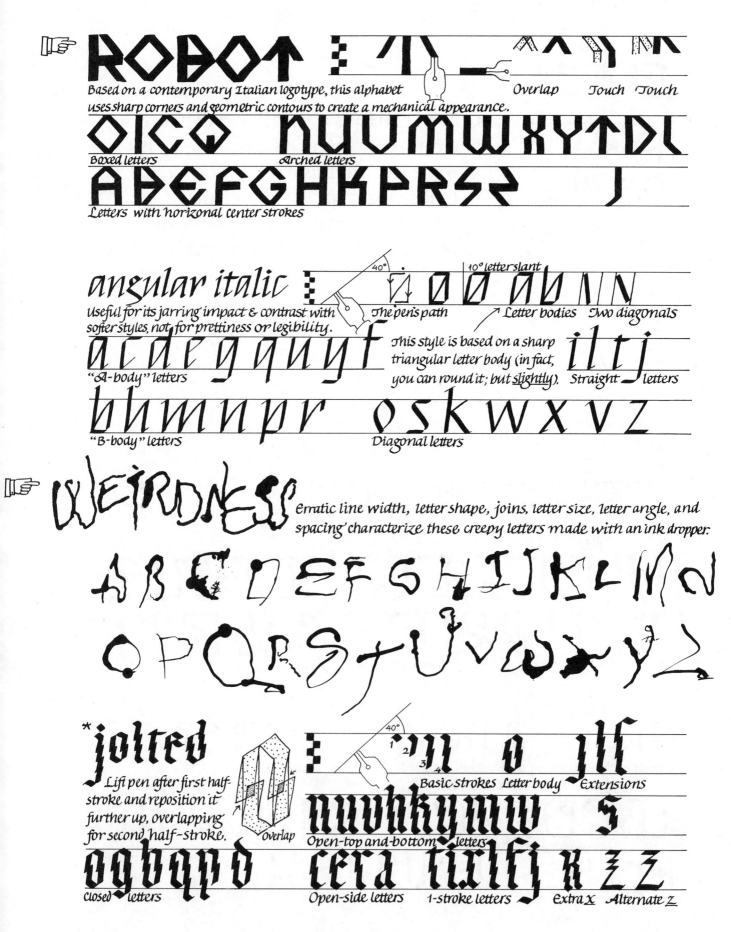

👉 **ROBOT** ↑ Overlap Touch Touch

Based on a contemporary Italian logotype, this alphabet
uses sharp corners and geometric contours to create a mechanical appearance.

OICQ HVVMWXYTVI

Boxed letters Arched letters

ABEFGHKPRSZ J

Letters with horizonal center strokes

angular italic 40° 10° letter slant

Useful for its jarring impact & contrast with
softer styles, not for prettiness or legibility.

The pen's path Letter bodies Two diagonals

acdegqnuyf This style is based on a sharp **iltj**
 triangular letter body (in fact,
"A-body" letters you can round it; but slightly). Straight letters

bhmnpr oskwxvz

"B-body" letters Diagonal letters

👉 **WEIRDNESS** Erratic line width, letter shape, joins, letter size, letter angle, and
 spacing characterize these creepy letters made with an ink dropper.

AB C D E F G H I J K L M N

O P Q R S T U V W X Y Z

*⚹ **jolted** 40°

Lift pen after first half- Basic strokes Letter body Extensions
stroke and reposition it
further up, overlapping Overlap
for second half-stroke. **nuvhkymw s**

 Open-top and-bottom letters

ogbqpd cera tirlfj x z z

Closed letters Open-side letters 1-stroke letters Extra x Alternate z

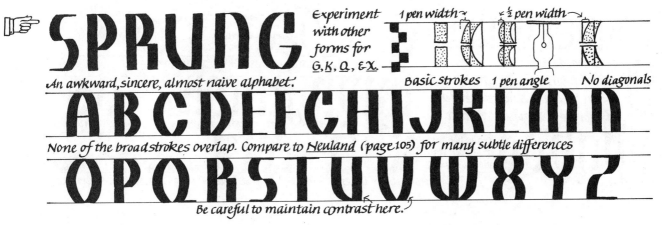

SPRUNG

An awkward, sincere, almost naive alphabet.

Experiment with other forms for G, K, Q, & X.

1 pen width → ½ pen width →

Basic strokes · 1 pen angle · No diagonals

A B C D E F G H I J K L M N

None of the broad strokes overlap. Compare to Neuland (page 105) for many subtle differences

O P Q R S T U V W X Y Z

Be careful to maintain contrast here.

Sometimes you are asked to do ugly calligraphy (or 'malligraphy') to convey specific & startling visual effects. Work in an uncomfortable chair, with inappropriate, malfunctioning tools, preferably when you are in a bad mood. Do a second and third draft and choose all the worst letters for your final design.

junk

We need it for the Rummage Sale Tuesday, Oct. 2

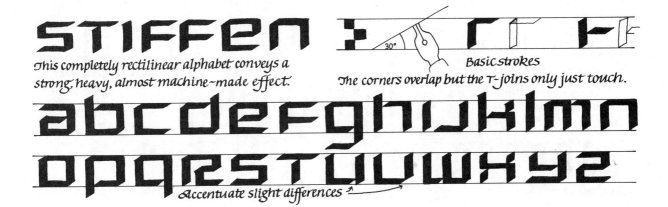

STIFFEN

This completely rectilinear alphabet conveys a strong, heavy, almost machine-made effect.

30°

Basic strokes

The corners overlap but the T-joins only just touch.

a b c d e f g h i j k l m n

o p q r s t u v w x y z

Accentuate slight differences

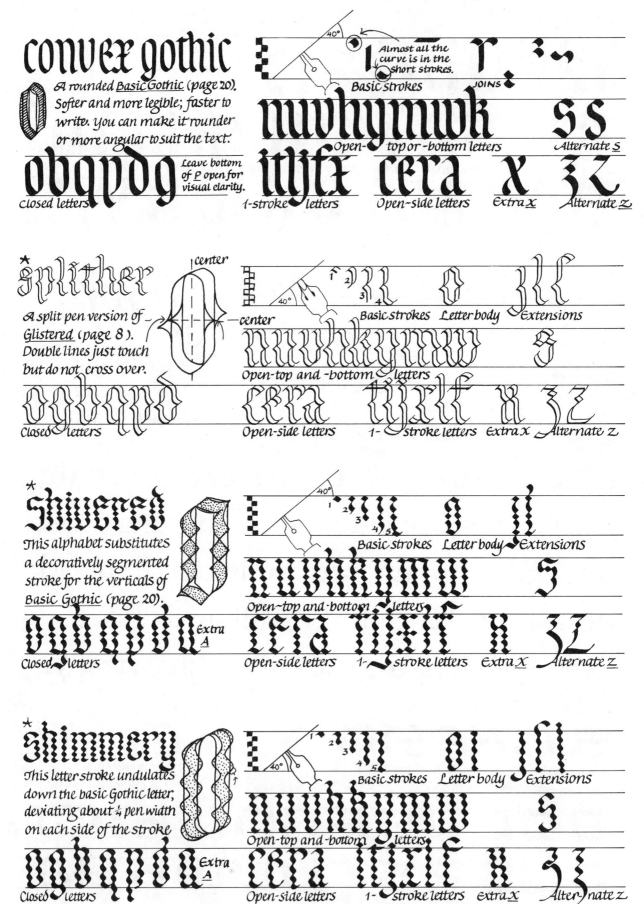

convex gothic

A rounded _Basic Gothic_ (page 20). Softer and more legible; faster to write. You can make it rounder or more angular to suit the text.

obqpdg Leave bottom of _P_ open for visual clarity.

Closed letters

40°

Almost all the curve is in the short strokes.

Basic strokes JOINS

nuvhymwk ss

Open- top or -bottom letters Alternate _s_

itljfx cera x zz

1-stroke letters Open-side letters Extra _x_ Alternate _z_

*splither

A split pen version of _Glistered_ (page 8). Double lines just touch but do not cross over.

ogbqpd

Closed letters

center / center

40°

Basic strokes Letter body Extensions

nuvhkymw s

Open-top and -bottom letters

cera tijrlf x zz

Open-side letters 1- stroke letters Extra _x_ Alternate _z_

*Shivered

This alphabet substitutes a decoratively segmented stroke for the verticals of _Basic Gothic_ (page 20).

ogbqpdq Extra _A_

Closed letters

40°

Basic strokes Letter body Extensions

nuvhkymw s

Open-top and -bottom letters

cera tijrlf x zz

Open-side letters 1- stroke letters Extra _x_ Alternate _z_

*shimmery

This letter stroke undulates down the basic Gothic letter, deviating about ¼ pen width on each side of the stroke

ogbqpdq Extra _A_

Closed letters

40°

Basic strokes Letter body Extensions

nuvhkymw s

Open-top and -bottom letters

cera tijrlf x zz

Open-side letters 1- stroke letters extra _x_ Alter-nate _z_

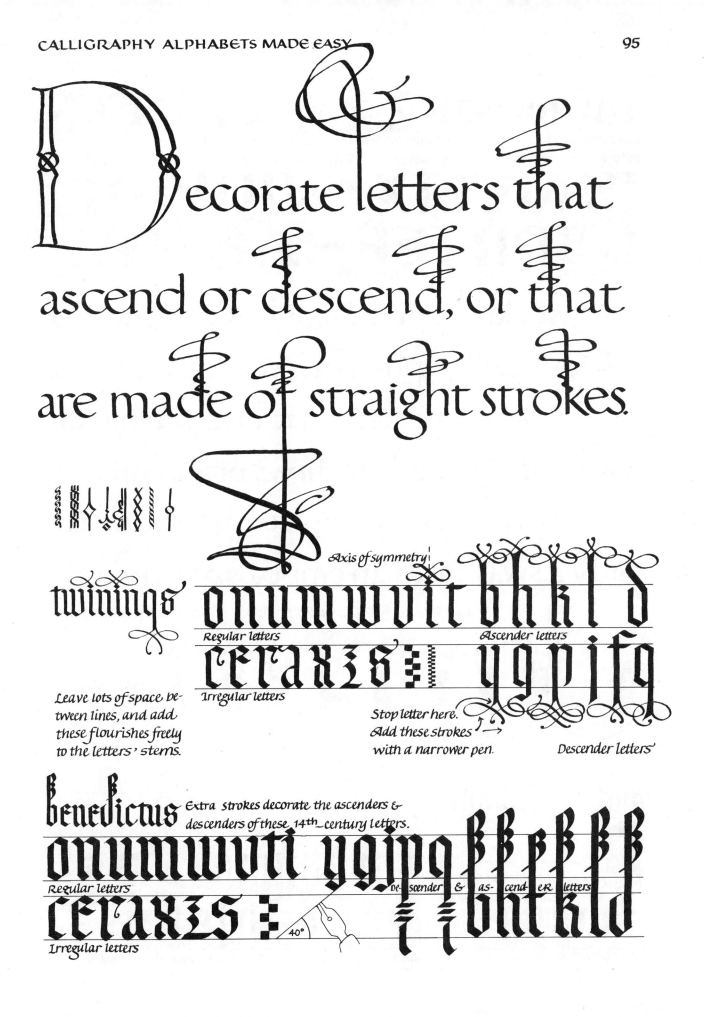

Decorate letters that ascend or descend, or that are made of straight strokes.

twinings

onumwvit bhkl d

Regular letters

Ascender letters

Axis of symmetry

ceraxis

ygpifg

Irregular letters

Leave lots of space between lines, and add these flourishes freely to the letters' stems.

Stop letter here.
Add these strokes
with a narrower pen.

Descender letters

benedictus Extra strokes decorate the ascenders & descenders of these 14th-century letters.

onumwvti ygipq

Regular letters

De-scender & as-cend-er letters

ceraxis

40°

bhtkld

Irregular letters

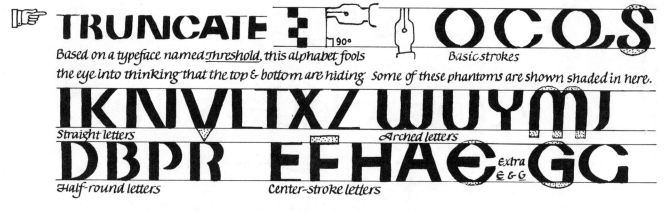

☞ **TRUNCATE** 90° **OCOS**

Based on a typeface named Threshold, this alphabet fools **Basic strokes**
the eye into thinking that the top & bottom are hiding *Some of these phantoms are shown shaded in here.*

IKNVLTXZ WUYMJ

Straight letters *Arched letters*

DBPR EFHAE Extra **GG**
 E & G

Half-round letters *Center-stroke letters*

The world of optical illusions is at the tip
of your calligraphy pen. You can enchant
the viewer's eye, charm it into seeing not
two dimensions but three, precious metals
instead of paper, complete letters where
only a swash and an empty space exist.

See Gothic Softlight (page 30) for details of this shading technique.

chrome

gothic lowlight 40°

Create the illusion of raised 1 2 3
letters lit from below, by **Basic strokes Fill with brush or solid pen.**
filling in a split-pen Gothic,
or another split style. **nuvhkymw** **SS**

 Open-top or ~bottom letters *Alternate S*

ogbqpd **cera zz itjxlf x**

Closed letters *Open-side letters Alternate z 1-stroke letters Extra x*

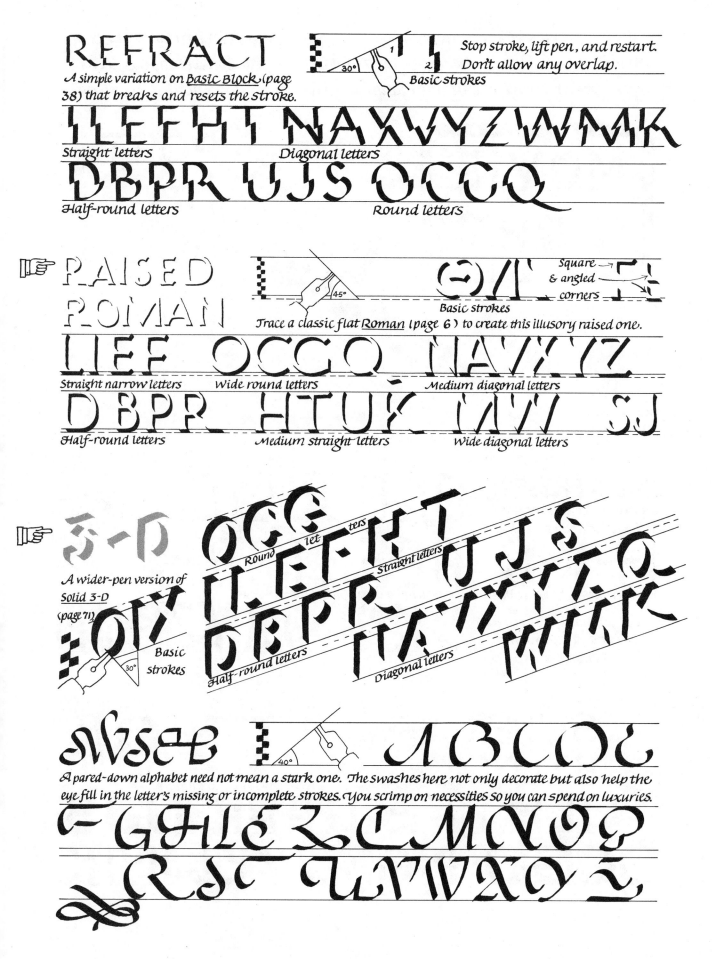

REFRACT

A simple variation on <u>Basic Block</u> (page 38) that breaks and resets the stroke.

Stop stroke, lift pen, and restart. Don't allow any overlap.

Basic strokes

30°

ILEFHT NAXVYZWMK

Straight letters Diagonal letters

DBPR UJS OCCQ

Half-round letters Round letters

RAISED ROMAN

Trace a classic flat <u>Roman</u> (page 6) to create this illusory raised one.

Basic strokes

45°

Square & angled corners

LIEF OCCQ NAVXYZ

Straight narrow letters Wide round letters Medium diagonal letters

DBPR HTUK WV SJ

Half-round letters Medium straight letters Wide diagonal letters

A wider-pen version of <u>Solid 3-D</u> (page 71)

Basic strokes

30°

OCCQ Round letters

ILEFHT Straight letters

UJS

DBPR Half-round letters

NAVXYZ Diagonal letters

WMK

A pared-down alphabet need not mean a stark one. The swashes here not only decorate but also help the eye fill in the letter's missing or incomplete strokes. You scrimp on necessities so you can spend on luxuries.

40°

ABCD EFGHIE KLMNOP QRST UVWXYZ

In the hands of a skilled calligrapher, the simplest poster can call up images of other kinds of signs in the urban landscape. The right alphabet style & letter arrangement create the movie marquee, lit-up neon, a stencilled warning:

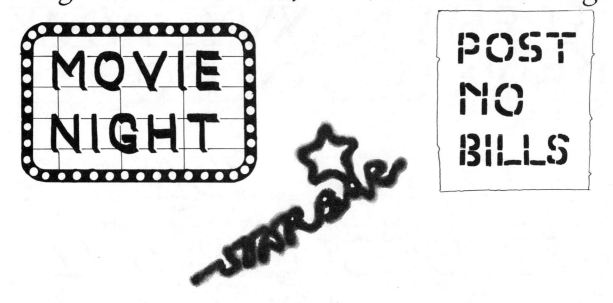

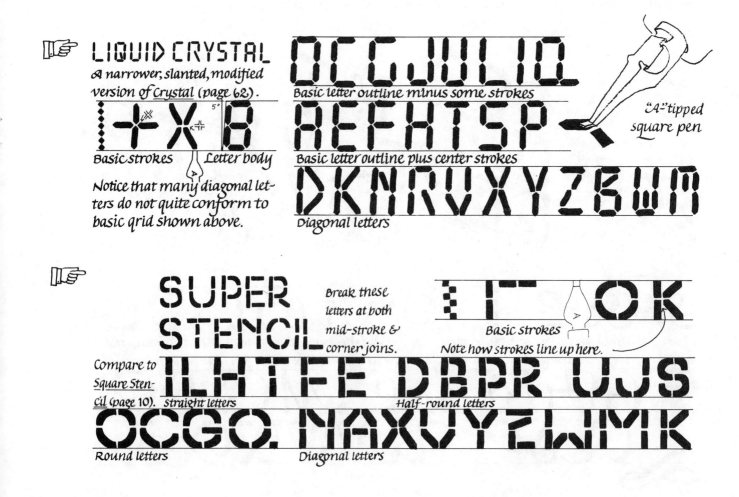

☞ **LIQUID CRYSTAL**
A narrower, slanted, modified version of Crystal (page 62).

Basic strokes Letter body

Notice that many diagonal letters do not quite conform to basic grid shown above.

OCGJWLIQ
Basic letter outline minus some strokes

AEFHTSP
Basic letter outline plus center strokes

DKNRVXYZBWM
Diagonal letters

"A" tipped square pen

☞ **SUPER STENCIL**

Break these letters at both mid-stroke & corner joins.

Basic strokes

Note how strokes line up here.

Compare to Square Stencil (page 10).

ILHTFE DBPR UJS
straight letters *Half-round letters*

OCGQ NAXVYZWMK
Round letters *Diagonal letters*

☞ **MONEON**

This alphabet, derived from a typeface, links stroke ends to imply a continuous pen line.

Basic strokes

ABCDEFGHIJKLMNO
PQRSTUVWXYZ DCSE

Alternate letters

☞ **MARQUEE**

Two pens combine to create a letter lit from the back, seen from the front.

1 1 O O 1 2 1 2

Basic strokes

ILHTFE DBPR UJS

Straight letters ½-round letters

OCGQ NAXVYZWMK

Round letters *Diagonal letters*

Rectangular "guidelines" are in fact inked in after letters are done, with gaps to reinforce illusion of letter solidity.

☞ **2½D**

A shadow heightens this alphabet's 'depth.'

OCG *Round letters*

ILEFHT *Straight letters*

OIX

DBPR *Half-round letters*

UJS

NAVXYZQ

WMK *Diagonal letters*

Basic strokes

☞ SPRAY **ABCDEFGHIJKLM**

Use airbrush for small size, or aerosol paint can for wall size, letters.. Move smoothly & quickly; experiment.

NOPQRSTUVWXYZ

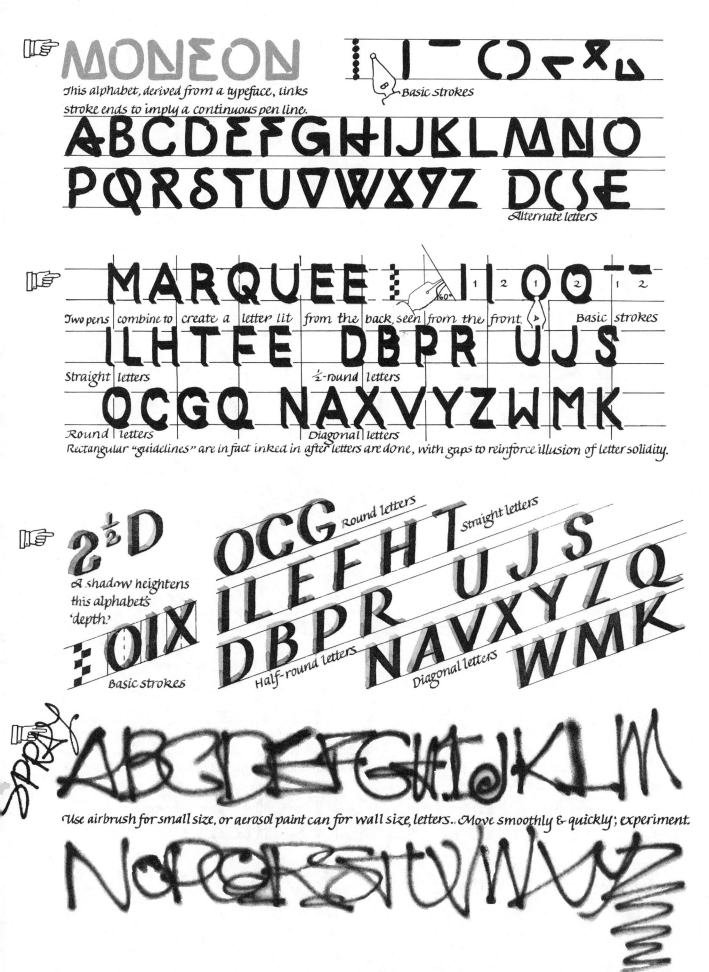

untogether

"Blow apart" a basic <u>Bookhand</u> (page 74) and let the eye reassemble it. Also useful for stencils.

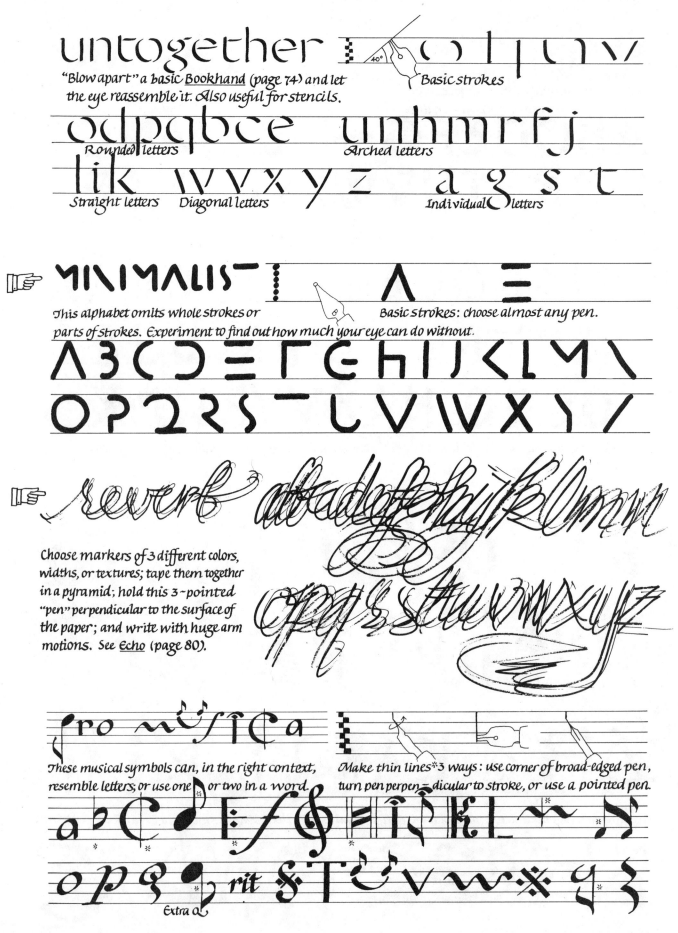

Basic strokes

Rounded letters Arched letters

Straight letters Diagonal letters Individual letters

MINIMALIS

This alphabet omits whole strokes or parts of strokes. Experiment to find out how much your eye can do without.

Basic strokes: choose almost any pen.

reverb

Choose markers of 3 different colors, widths, or textures; tape them together in a pyramid; hold this 3-pointed "pen" perpendicular to the surface of the paper; and write with huge arm motions. See <u>Echo</u> (page 80).

pro musica

These musical symbols can, in the right context, resemble letters; or use one or two in a word.

Make thin lines *3 ways: use corner of broad-edged pen, turn pen perpendicular to stroke, or use a pointed pen.

Extra a

alphabet

ALPHABET

shepherd

The most wonderful thing about the eye is its quest for meaning. It seeks letters, craves reading, squeezes information out of marks. A few letters read the same upside-down or mirrored (H, O, X, A); others (WOW!) reveal secret messages.

Read Inversions *by Scott Kim. McGraw-Hill, 1981.*

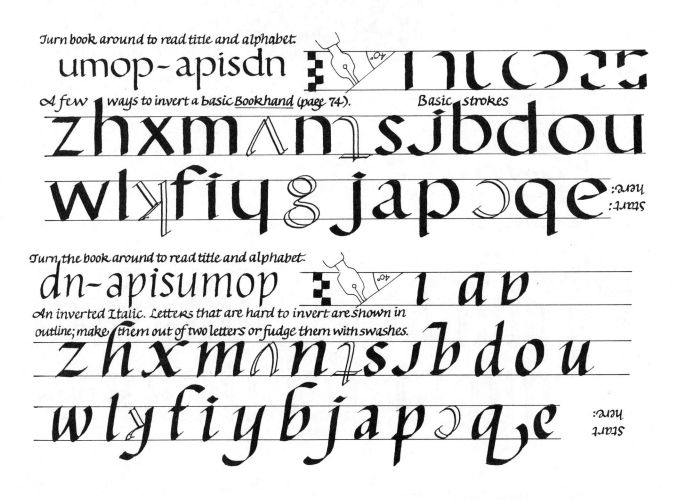

Turn book around to read title and alphabet.

umop-apisdn

A few ways to invert a basic Bookhand *(page 74).* *Basic strokes*

zhxmɯʌxhz nobdɹsɾbdou

wlʎ fiɥƃ jɐp ɔɐqɐ *Start here:*

Turn the book around to read title and alphabet.

dn-apisumop

An inverted Italic. Letters that are hard to invert are shown in outline; make them out of two letters or fudge them with swashes.

zhxmɯɯɯɐxhz nobdɹsɟbdou

wlʎ fiyɥ ɓjɐp ɔɐqɐ *Start here:*

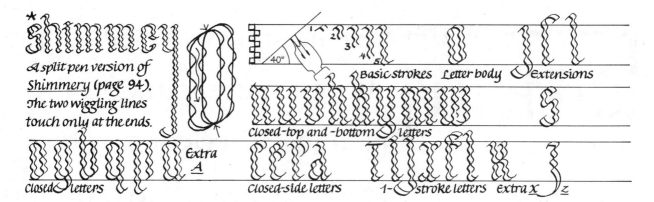

Shimmey

A split pen version of *Shimmery* (page 94). The two wiggling lines touch only at the ends.

40° Basic strokes Letter body Extensions

Closed-top and -bottom letters

closed letters Extra *A*

Closed-side letters 1-stroke letters extra *X* *Z*

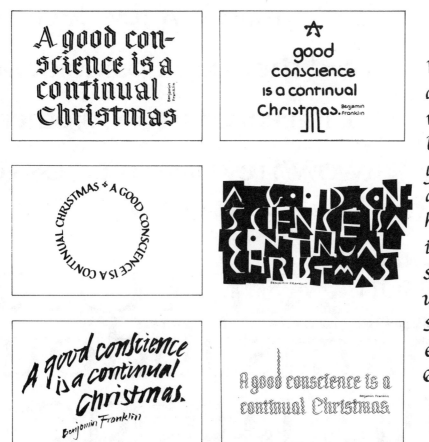

A good conscience is a continual Christmas
Benjamin Franklin

A good conscience is a continual Christmas. Benjamin Franklin

A GOOD CONSCIENCE IS A CONTINUAL CHRISTMAS

A good conscience is a continual Christmas. Benjamin Franklin

A good conscience is a continual Christmas Benjamin Franklin

Write your favorite quotation 6 different ways with 6 different letter styles, to jolt yourself out of your accustomed design habits. Each new look implies a different speaker, audience, volume, & tone of voice. Start designing anew each day; compare all 6 versions at week's end.

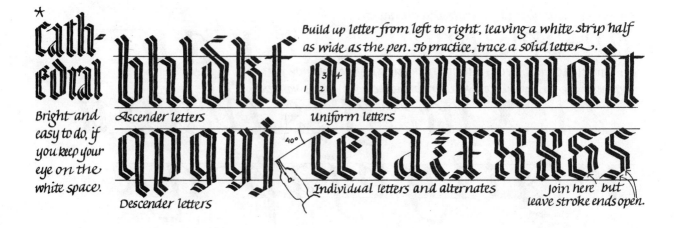

cath-edral

Bright and easy to do, if you keep your eye on the white space.

Build up letter from left to right, leaving a white strip half as wide as the pen. To practice, trace a solid letter.

Ascender letters Uniform letters

Descender letters Individual letters and alternates join here but leave stroke ends open.

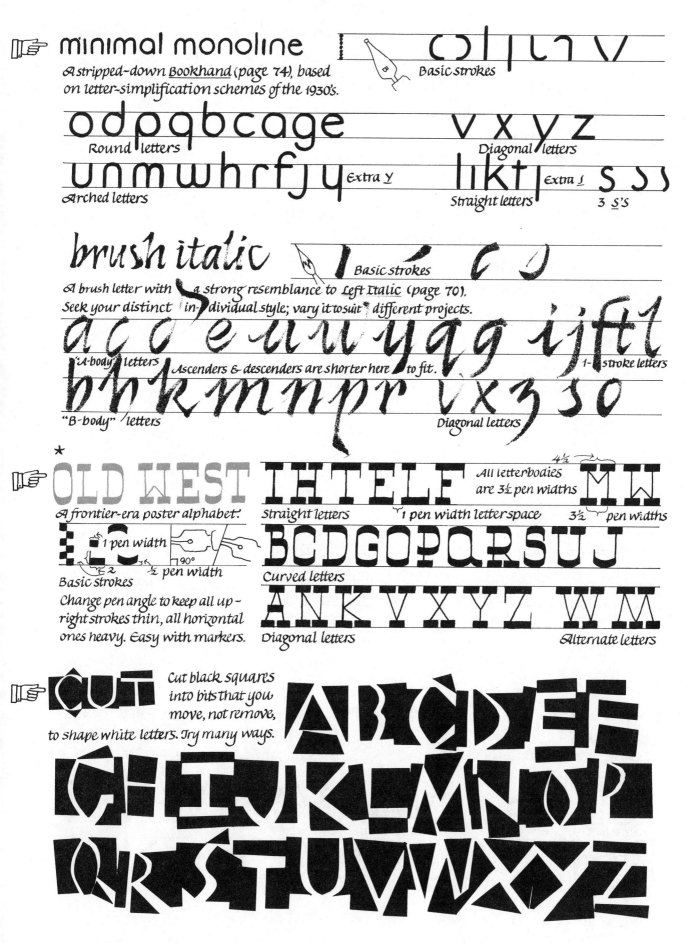

☞ **minimal monoline**

A stripped-down <u>Bookhand</u> (page 74), based on letter-simplification schemes of the 1930's.

Basic strokes

o d p q b c a g e
Round letters

v x y z
Diagonal letters

u n m w h r f j y Extra *y*
Arched letters

l i k t l Extra *s*
Straight letters

s s s
3 *s*'s

brush italic

Basic strokes

A brush letter with a strong resemblance to <u>Left Italic</u> (page 70). Seek your distinct in-dividual style; vary it to suit different projects.

a c d e u u y a g i j f t l
"A-body" letters Ascenders & descenders are shorter here to fit. 1- stroke letters

b h k m n p r v x z s o
"B-body" letters Diagonal letters

*

☞ OLD WEST

A frontier-era poster alphabet.

1 pen width
½ pen width
90°
Basic strokes

Change pen angle to keep all up-right strokes thin, all horizontal ones heavy. Easy with markers.

I H T E L F
Straight letters 1 pen width letterspace 3½ pen widths

All letterbodies are 3½ pen widths 4½

B C D G O P Q R S U J
Curved letters

A N K V X Y Z W M
Diagonal letters Alternate letters

☞ **CUT** Cut black squares into bits that you move, not remove, to shape white letters. Try many ways.

**A B C D E F
G H I J K L M N O P
Q R S T U V W X Y Z**

Now that you know nearly 300 alphabets, expand your repertoire by at least an order of magnitude; review the relativity of a letter's weight. The size of the pen that you have or the letter that you want are not individually crucial; it is their *ratio* which matters when you letter a style. The width of the pen determines the height of the letter. Each style in this book has a recommend ratio; use it to begin with, modifying it later if you prefer. But always, if you change letter height, change pen width.

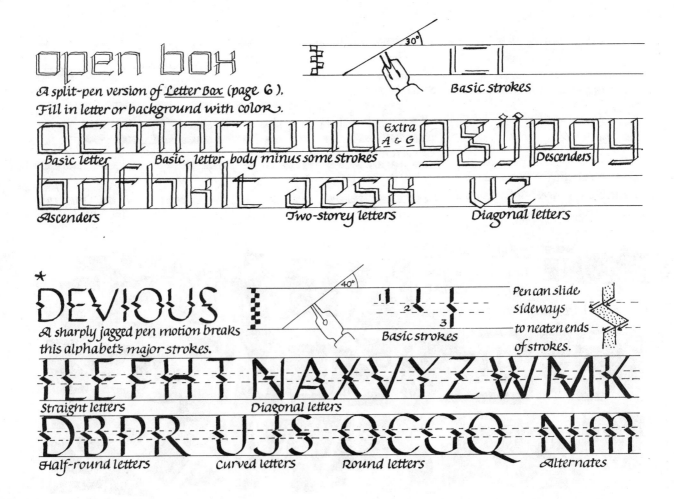

open box

A split-pen version of Letter Box (page 6).
Fill in letter or background with color.

Basic strokes

Basic letter Basic letter body minus some strokes Extra A & G Descenders

Ascenders Two-storey letters Diagonal letters

★ DEVIOUS

A sharply jagged pen motion breaks
this alphabet's major strokes.

Basic strokes

Pen can slide sideways to neaten ends of strokes.

Straight letters Diagonal letters

Half-round letters Curved letters Round letters Alternates

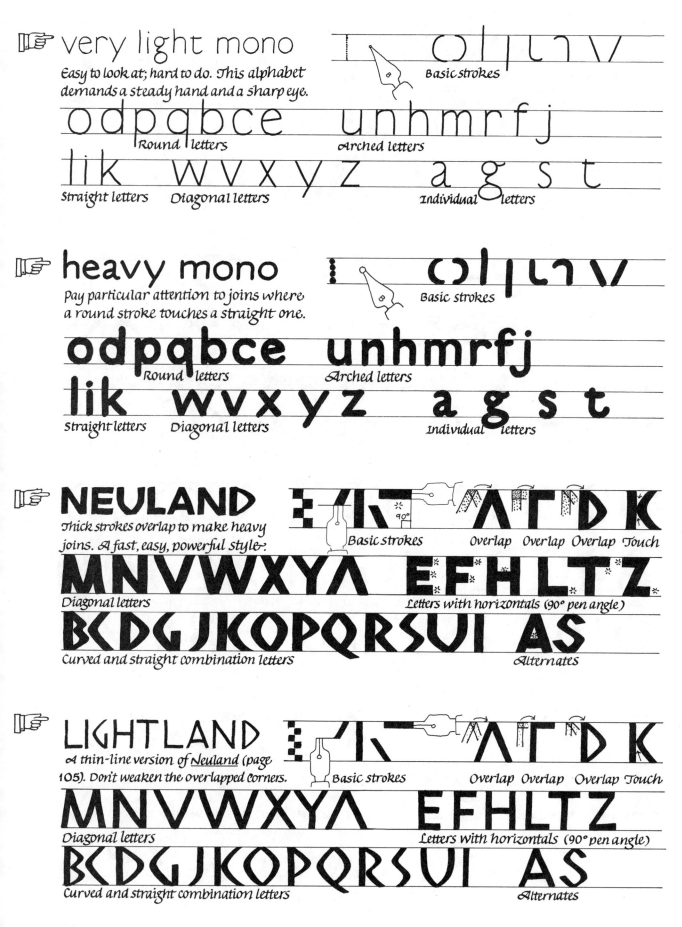

☞ **very light mono**

Easy to look at; hard to do. This alphabet demands a steady hand and a sharp eye.

Basic strokes

odpqbce unhmrfj

Round letters Arched letters

lik wvxyz a g s t

Straight letters Diagonal letters Individual letters

☞ **heavy mono**

Pay particular attention to joins where a round stroke touches a straight one.

Basic strokes

odpqbce unhmrfj

Round letters Arched letters

lik wvxyz a g s t

Straight letters Diagonal letters Individual letters

☞ **NEULAND**

Thick strokes overlap to make heavy joins. A fast, easy, powerful style.

Basic strokes Overlap Overlap Overlap Touch

MNVWXYA EFHLTZ

Diagonal letters Letters with horizontals (90° pen angle)

BCDGJKOPQRSUI AS

Curved and straight combination letters Alternates

☞ **LIGHTLAND**

A thin-line version of *Neuland* (page 105). Don't weaken the overlapped corners.

Basic strokes Overlap Overlap Overlap Touch

MNVWXYA EFHLTZ

Diagonal letters Letters with horizontals (90° pen angle)

BCDGJKOPQRSUI AS

Curved and straight combination letters Alternates

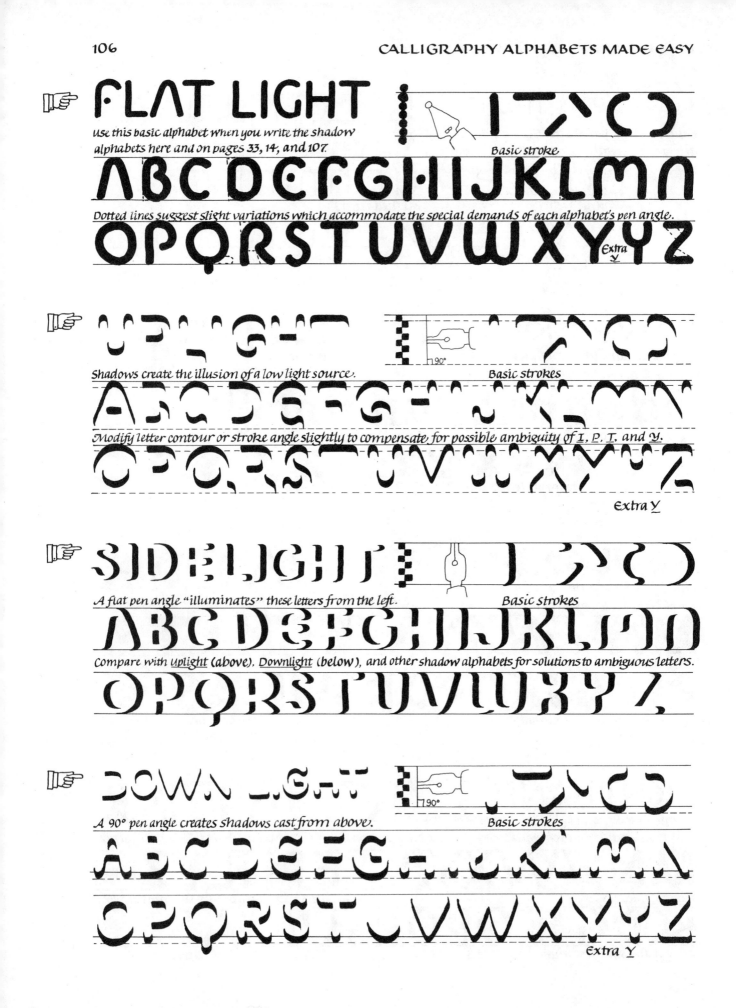

☞ FLAT LIGHT

use this basic alphabet when you write the shadow alphabets here and on pages 33, 14, and 107.

Basic stroke

ABCDEFGHIJKLMN

Dotted lines suggest slight variations which accommodate the special demands of each alphabet's pen angle.

OPQRSTUVWXY Y Z

Extra Y

☞ UPLIGHT

Shadows create the illusion of a low light source.

Basic strokes

ABCDEFGHIJKLMN

Modify letter contour or stroke angle slightly to compensate for possible ambiguity of I, P, T, and Y.

OPQRSTUVWXYZ

Extra Y

☞ SIDELIGHT

A flat pen angle "illuminates" these letters from the left.

Basic strokes

ABCDEFGHIJKLMN

Compare with uplight (above), Downlight (below), and other shadow alphabets for solutions to ambiguous letters.

OPQRSTUVWXYZ

☞ DOWN LIGHT

A 90° pen angle creates shadows cast from above.

Basic strokes

ABCDEFGHIJKLMN

OPQRSTUVWXYZ

Extra Y

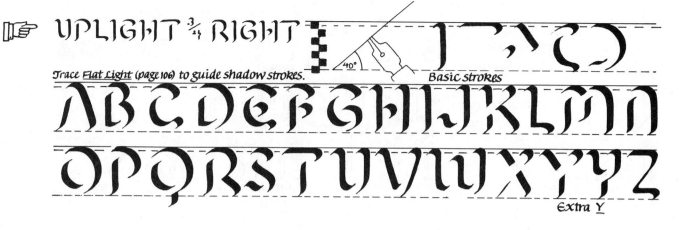

☞ UPLIGHT ¾ RIGHT

Trace Flat Light (page 106) to guide shadow strokes.

40°

Basic strokes

ABCDEFGHIJKLMN
OPQRSTUVWXYYZ

Extra Y

S O L S T I C E (vertical, left)

December 21ˢᵗ marks the winter solstice, when the day is shortest & the night longest in the Northern hemisphere.

S O L S T I C E (vertical, center)

Practice vertical lettering: flush left and right, and centered, with a variety of styles, making tiny spacing adjustments

S O L S T I C E (vertical, right)

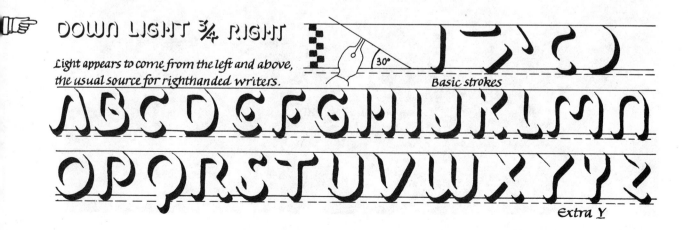

☞ DOWN LIGHT ¾ RIGHT

Light appears to come from the left and above, the usual source for righthanded writers.

30°

Basic strokes

ABCDEFGHIJKLMN
OPQRSTUVWXYYZ

Extra Y

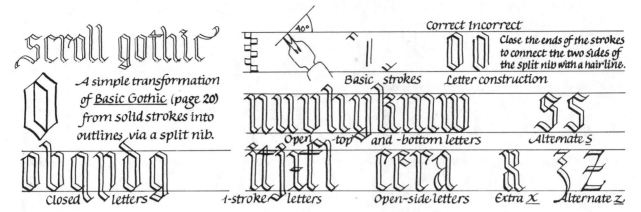

scroll gothic

A simple transformation of <u>Basic Gothic</u> (page 20) from solid strokes into outlines, via a split nib.

Closed letters

Correct Incorrect

Close the ends of the strokes to connect the two sides of the split nib with a hairline.

Basic strokes Letter construction

Open -top- and -bottom letters Alternate *S*

1-stroke letters Open-side letters Extra <u>X</u> Alternate <u>Z</u>

Because the custom of sending out cards at Christmastime was popularized by the Victorians, it has come to be linked to the Gothic Revival style that was all the rage at the time. You can combine "Christmas letters" and "Voice of God capitals" with medieval borders to infuse your handlettered greetings with the peculiar flavor of both the 19th and the 14th centuries. Fill the capital strokes and interior letter-spaces with texture, color, gold, decorations or seasonal ornaments. Or create a 20th century design by treating Gothic letters as abstractions.

Sing we all noël

Make these hexagonal kaleidoscopic letter multiples on a grid to guide placement. No two are alike!

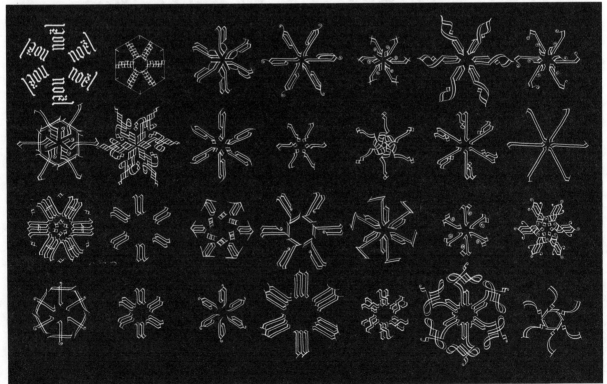

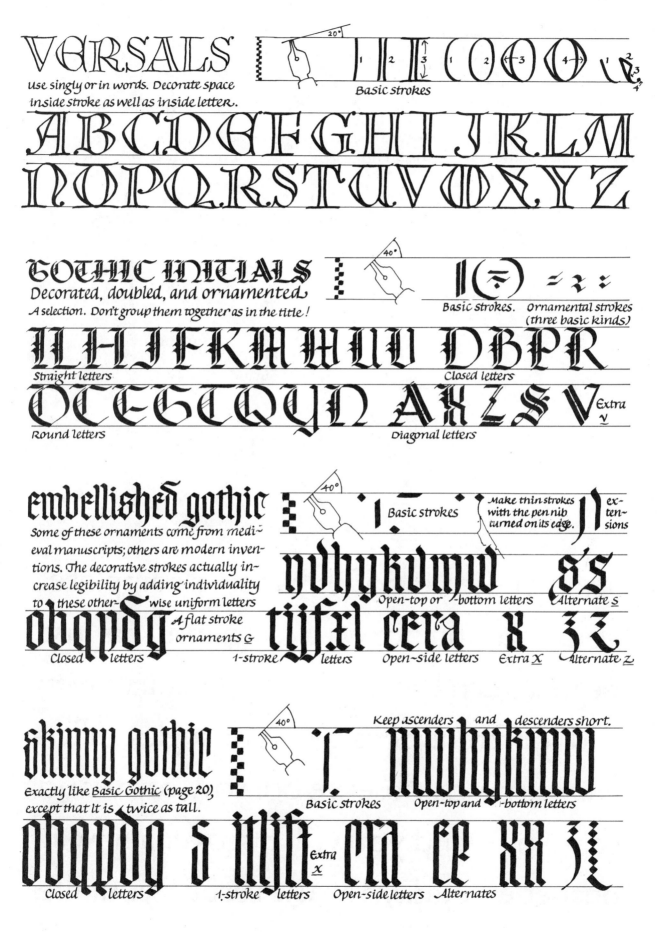

VERSALS

use singly or in words. Decorate space inside stroke as well as inside letter.

Basic strokes

A B C D E F G H I J K L M
N O P Q R S T U V W X Y Z

GOTHIC INITIALS

Decorated, doubled, and ornamented. A selection. Don't group them together as in the title!

Basic strokes. Ornamental strokes (three basic kinds)

I L H J F K M W U D B P R
Straight letters Closed letters

O C E G C Q Y N A K Z S V Extra v
Round letters Diagonal letters

embellished gothic

Some of these ornaments come from medieval manuscripts; others are modern inventions. The decorative strokes actually increase legibility by adding individuality to these otherwise uniform letters

Basic strokes Make thin strokes with the pen nib turned on its edge. extensions

n v d h y k v m w s s
Open-top or -bottom letters Alternate s

o b q p d g A flat stroke ornaments G
Closed letters

t i j f l e e r a x z z
1-stroke letters Open-side letters Extra x Alternate z

skinny gothic

Exactly like Basic Gothic (page 20), except that it is twice as tall.

Basic strokes Keep ascenders and descenders short.

n u v h y k m w
Open-top and -bottom letters

o b q p d g s i t l i f t e r a e e x x z z
Closed letters 1-stroke letters Open-side letters Alternates Extra x

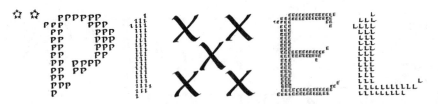

Letters can be built up of almost anything, even themselves. Try grids of varying fineness or coarseness, depending on the letter and the viewing distance. Compare First Impressions (page 73), Cubes (page 63), and Alias 1 & 2 (page 72).

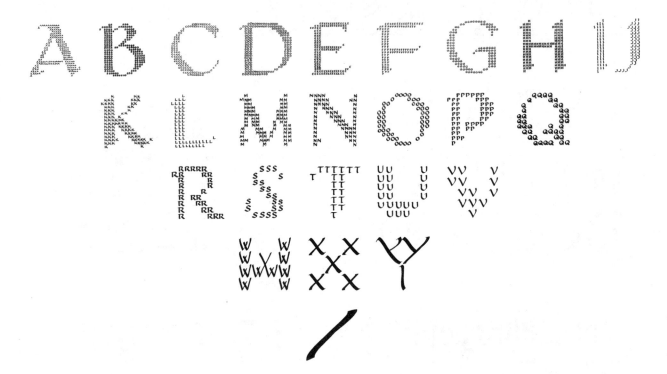

Though the year of alphabets is complete, your acquaintance with calligraphy has just begun. Turn back to page 1, & start over with different pens, different angles, different purposes. Observe, borrow, copy, and combine—and you will discover a new alphabet every day for the rest of your life.

INDEX